Light and Love

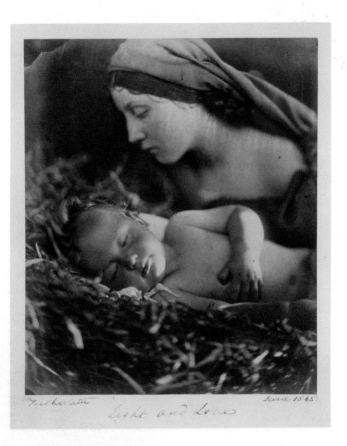

Light and Love

The Extraordinary Developments of Julia Margaret Cameron and Mary Hillier

Kirsty Stonell Walker

UNICORN

First published by Unicorn
an imprint of Unicorn Publishing Group LLP, 2020
5 Newburgh Street
London W1F 7RG
www.unicornpublishing.org

Cover image: detail from *Call, I Follow, I Follow, Let Me Die!*
(1867) Julia Margaret Cameron
Frontispiece: *Light and Love* (1865) Julia Margaret Cameron

Every effort has been made to trace copyright holders and
to obtain their permission for the use of copyright material.
The publisher apologises for any errors or omissions and
would be grateful if notified of any corrections that should be
incorporated in future reprints or editions of this book.

ISBN 978-1-913491-06-2
10 9 8 7 6 5 4 3 2 1

Designed by Felicity Price-Smith
Printed in Europe on behalf of Latitude Press Ltd

Contents

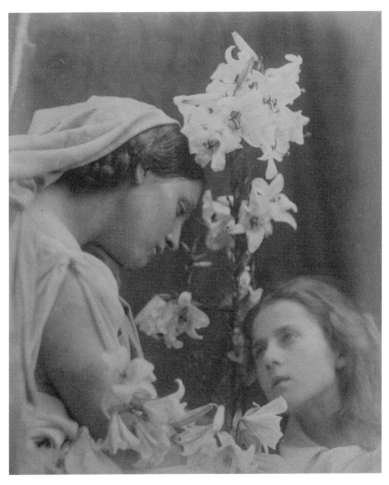

The Communion (1870)
Julia Margaret Cameron

Acknowledgements

As with everything in life, this book would not exist without the help and support of many wonderful people that I have had the good fortune to have in my life, either for a day or on a permanent basis because they are stuck with me now. I would like to thank Brian Hinton, Kate Tiley and Rachel Flynn at Dimbola Lodge; Grace Timmins at the Tennyson Research Centre; Tim Lindholm for the very kind use of his photograph and his encouragement; to Cyllena's generous and gracious descendant, Sharlene Shipman Baker for the use of her photograph and the wonderful information; Gail Downey for introducing me to Evie Hodgson, and Evie for introducing me to Muriel Campin-Lowe, and for saving as much of her archive as possible when she died. I am forever indebted to you for that, Evie: thank you.

Thanks as ever go to my best Girl Gang at Unicorn – Lucy, Felicity and Louise, and to Emily and Ramona, for comments and corrections. Thanks to my agent and wearer of the reddest lipstick in the world, Esther Harris, the Bebe to my Frasier. Appreciative noises are as always directed towards my support network – to Stephanie Holman (resting ninja), Stephanie Chatfield (goodness itself), and Mr Walker for putting up with all the books and me.

My interest in Julia Margaret Cameron and Mary Hillier started with the Pre-Raphaelites and Tennyson, while I was doing my MA thesis in the early 2000s. By that time the heroic act of saving Julia's home, Dimbola Lodge in Freshwater on the Isle of Wight,

from demolition had been achieved. It is now a museum, and now everyone can experience the house where models sat for hours, as still as they possibly could while Julia shouted at them, and where Julia and Mary rushed up and down the stairs with the precious glass plates. I encourage you all to visit, and then pop next door to Farringford, Tennyson's home, which is also open to the public now for guided tours. It's what Julia would have wanted.

As always, this book is dedicated to the wondrous Lily-Rose, who is now the age Mary Hillier was when Julia Margaret Cameron first saw her.

Introduction

AN IMAGE FROM THE WET COLLODION process can be seen in three parts: the glass, the image and the paper. The glass has a journey to make before it becomes a perfectly cut piece, ready to be coated in collodion. The paper has quite another journey until, in a perfect rectangle of sensitivity, it can reveal the work that has gone before. What joins these two pieces is the image, a fleeting moment in time that has vanished forever before the paper even begins to show signs that it ever existed. What happens between the glass and the paper is a lot of work and often luck. The peril and joy of the wet collodion process is that each print shows the story of the image-making. Mistakes, disasters, triumphs and unexpected joys are apparent, though not always at first. Only at the end can you see if the decisions you made were correct, if the actions you performed were good enough, and if fate has not intervened to turn all your work to nothing. In that way a life, and a biography, is much like a photograph. It is the resultant print of all that has occurred, and often cheerfully, or tragically, unexpected in its results. Lives that cross and influence others mark their glass in ways that can only be seen at their conclusion. Our exposure to others changes us in ways that can be unexpected.

On the face of it, the relationship between Julia Margaret Cameron, a daughter of the colonies, and Mary Ann Hillier, a maid from the Isle of Wight, seems improbable beyond that of mistress and

servant. One was in her late forties, the other a teenager; Julia had seen a number of different continents, Mary had seen one village in the corner of a small rural island. However, as Julia herself acknowledged in her autobiography *Annals of My Glasshouse* of 1874, there existed between the two women the bond of artist and muse. Even if that had only been the fancy of an artistic, bohemian woman, the life experiences they shared, and the life Mary lived after Julia's death, have the mark of an image created earlier. By capturing Mary in her pioneering photographs Julia created the image of her ideal of the pinnacle of womanhood, of motherhood, a 'Madonna', the role that Julia herself wished to emulate in her life. Julia's images of Mary were a form of wish fulfilment, of living out a fantasy which she did not quite manage in real life. However, it is through Julia's treatment of Mary that we see her nobleness. Unlike some of Julia's contemporary photographers who dressed their women in rags and degradation, Julia crowned her models in stars, sometimes literally, and never allowed her parlour maid to be seen as anything other than perfection. Mary allows us to see the beauty of Julia's vision, not just in photography but also in life. For Julia, women were not things to look down on and feel superior to: they were examples of magnificence.

Mary was the only one of Julia's models who spanned all eleven years of her photographic career in England, a constant in her photographs from the first Madonnas to the Tennysonian heroines that drew her time in Freshwater, on the Isle of Wight, to a close. When Julia began again in Ceylon she searched for young, beautiful girls as her models, but never found the right ones to embody the parts she wished to cast them in. The vessel of Julia's artistic vision was Mary, still and unchanging, yet able to portray realistically the Virgin Mary, Bathsheba, or Tennyson's Maud. It would be easy to lose Mary Hillier within a biography of Julia, but by the very nature of Julia's art Mary, though often wordless, is there for us to see, the personification of Julia's whispering muse, as

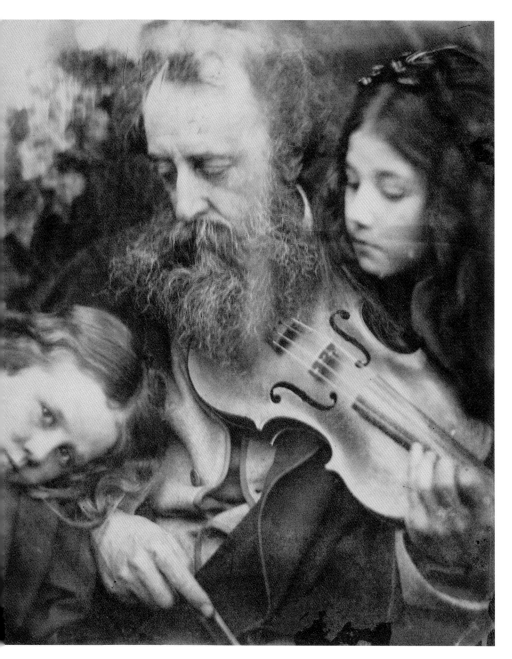

The Whisper of the Muse (April 1865) Julia Margaret Cameron

surely as the little girls who whispered in the ear of George Frederic Watts. Together, Julia and Mary become the fulfilment of the act of image creation: Julia acting as preparation, Julia and Mary capturing the moment, and Mary held up as the evidence of the work. Even after death Julia and Mary remained together as a partnership in retellings of the golden years in Freshwater, archetypal of a mistress and her maid, but also of an artist and her muse.

Throughout I will call Julia Margaret Cameron 'Julia' and Mary Hillier 'Mary': since it is their lives we are concerned with I'm sure they will forgive a little familiarity. However, as you will see, names are often repeated, and the bevies of 'Julias', 'Adelines' and 'Marys' necessitate using fuller names occasionally in order to keep it all clear. I have also used the older colonial names for countries and regions: Sri Lanka is 'Ceylon' and Kolkata is 'Calcutta', as that is how our protagonists would have known them.

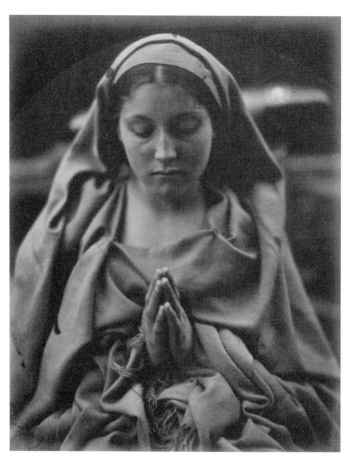

St Agnes (1872) Julia Margaret Cameron

Family Trees

JULIA MARGARET CAMERON

Ambroise Pierre
Antoine de l'Étang *married 1788*
1757–1840

Therésè Josephe
Blin Grincourt
1768–1866

Julia Adeline
Antoinette de l'Étang
1791–1866
married 1813
Edward Impey
1785–1858

Ambroise
de l'Étang
1792–1820

Adeline Maria
de l'Étang
1793–1845
married 1811
James Pattle
1775–1845

Virginie
de l'Étang
1795–1858
married 1822
Samuel Beadle
1790–1879

Eugène
de l'Étang
1803–1829

Adeline
Maria Pattle
1812–1836
married 1832
Colin Mackenzie
1806–1881

James Rocke
Mitford Pattle
1813–1813

Eliza Ann
Julia Pattle
1814–1818

Julia Margaret
Pattle
1815-1879
married 1838
Charles Hay Cameron
1795–1880

Sara Monckton
Pattle
1816–1887
married 1835
Henry Thoby Prinsep
1793–1878

Julia Hay Cameron
1838–1873
married 1859
Charles Loyd Norman
1833–1889

Eugene Hay Cameron
1840–1885
married 1862
Caroline Catherine Brown
1839–1917

Ewen Wrottesley
Hay Cameron
1843–1889
married 1869
Annie Eisdell Chinery
1851–1925

John Hillier *married 1838* Martha Ryall
1804–1885 1808–1887

William Hillier	Walter Hillier	Sophia Hillier	Mary Ann Hillier	George Hillier
1839–1907	1842–1920	1845–1906	1847–1936	1850–1924
			married 1877	
			Thomas Gilbert	
			1848–1929	

...a Mary ...ilbert	Margery Gilbert	Thomas Harold Herbert Gilbert	John William Rhyle Gilbert
...8–1929	1882–1968	1885–1918	1889–1955
	married 1903	*married 1914*	*married 1926*
	Carl Joseph Platte	Ethel Kelleway	Dorothy Joiner
	1884–1951	1886–1973	1895–1939

George Frederick Blackman Gilbert	Adeline Mary Rhyle Gilbert	Ralph Denison Gilbert	Godfrey Searle Gilbert
1880–1968	1884–1972	1886–1974	1891–1915
married 1918	*married 1916*	*married 1922*	
Charlotte Smith	Herbert George Earl	Mabel Howell	
1883–1971	1888–1959	1892–1985	

Maria Theodosia Pattle	Louisa Colebrook Pattle	Virginia Pattle	Harriott Trevor Charlotte Pattle	Sophia Ricketts Pattle
1818–1892	1821–1873	1827–1910	1828–1828	1829–1911
married 1837	*married 1838*	*married 1850*		*married 1847*
John Jackson	Henry Vincent Bayley	Charles James		John Warrender
1805–1887	1816–1873	Somers-Cocks		Dalrymple
		1819–1883		1824–1888

Hardinge Hay Cameron	Charles Hay Cameron	Henry Herschel Hay Cameron
1846–1911	1849–1891	1852–1911
married 1879		
Catherine Mcleod 1859–1880		
married 1884		
Adeline Annie Blake		
1862–1947		

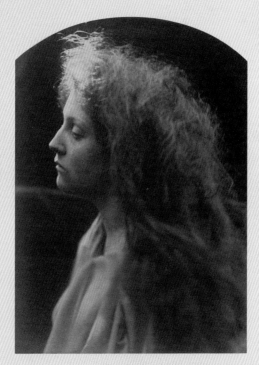

The Angel at the Tomb (1869)
Julia Margaret Cameron

Julia before Mary

WHEN TAKING WET COLLODION photographs, the very first job is to clean your plate. Polish, polish, polish until it squeaks and sparkles. Then the plate is delicately balanced on the fingertips of your right hand while egg white is drawn around the edges, preventing the collodion from running off. Collodion, a wicked mixture of very toxic chemicals including ether, is then poured on to the centre and the plate delicately tipped to cover the surface, like coating a baking tray with oil; the excess is tilted off into a bottle. The smell is overpowering. The wet plate is then immersed into a bath of silver nitrate, to sensitise it to light, for three minutes. With a minute to go, the lights in the darkroom are turned off, leaving only red lights on, so that your eyes can get used to the darkness. When the three minutes are up the plate is lifted out, the silver nitrate wiped from the back, and the sensitive plate is placed into a wooden holder and kept dark by a wooden slide until exposure.

The Chevalier Ambroise Pierre Antoine de l'Étang (no date) J. Gillis

CHAPTER ONE

Pray God bring Father safely Home

THE HEART OF THIS STORY is the understanding between a mistress and her loyal servant, so an ideal place to start is with just such a relationship. Our first mistress in the story is the Queen of France, and her servant is the Chevalier Ambroise Pierre Antoine de l'Étang. The Chevalier had followed his father into royal service, aged only thirteen, becoming an officer in the *garde du corps* of Louis XVI and superintendent of the royal stud farm. Only a few years younger than the Queen, the bright, handsome young Chevalier harboured a deep devotion to Marie-Antoinette. According to family legend the devotion raised the suspicion of the King, who exiled the handsome young horseman from his beloved Versailles to colonial India, to a regiment of Spahis stationed at Pondicherry.[1]

An even more romantic and fantastical story of the dashing Chevalier places him in the revolutionary prison cell of his Queen, from which he was able to effect a safe passage clutching a miniature of Marie-Antoinette which he would carry with him to his grave. Such romance attached to a soldier's career path could be dismissed as the stuff of fiction but for the fact that the governor of the province that the Chevalier would call home for the rest of his life apparently had strict instructions not to let him leave India.

Despite the abrupt manner of his departure the Chevalier did

1. Quentin Bell, *Virginia Woolf: A Biography* (London: Pimlico, 1972, 1996), p. 14.

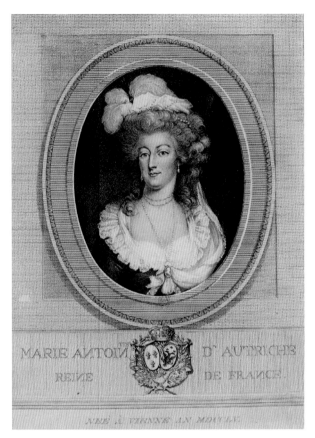

Josèphe-Jeanne Marie-Antoinette (1755–1793)
unknown artist

not show any great desire to return to France, possibly because the France he had known and loved had been sharply ended with a guillotine blade. Also, his life in India was not without comfort and privilege. In 1788 he married Thérèse Josephe Blin de Grincourt, daughter of a French colonialist, born in India in 1768. Although briefly a prisoner of the British forces that captured Pondicherry in 1793, the Chevalier, quickly freed and under the subsequent

Franco-British peace continued his career with horses. He ran a riding school in Calcutta and practised as an equine vet. In 1802 he was appointed veterinary surgeon to the bodyguard of the Governor-General of Bengal and ran the riding school for the Nawab of Oudh. The Governor-General of India, Francis Rawdon-Hastings, 1st Marquess of Hastings, wrote of the Chevalier that he was a man of exemplary character and polished manners. The next Governor-General, Lord William Bentinck, looked on him favourably as well and made him the head of the East India Company's stud at Ghazepore until his death in 1840.[2] The Chevalier was buried, according to his fanciful and romantic descendants, clutching the image of Marie-Antoinette to his breast.[3] Were it not for his exile, he would have suffered the same fate as this most beloved of mistresses; his exile had undoubtedly saved his life.[4]

Thérèse de l'Étang had never seen France, but held a great desire for what she felt was her spiritual 'homeland'. Her husband's tales of the golden years at Versailles must have fuelled this fervent wish, but unlike many of the French colonists her matrilineal roots lay thousands of miles from Paris. Within the family tree nestled a woman whose features were to echo for generations: she was a high-born Bengali, who Gallicised her Indian name to Marie Monique on her marriage to a Frenchman in the employ of the empire.[5] Her Indian roots were erased by her title, but her dark skin and features would be passed down through her daughters for many generations. Madame de l'Étang's marriage produced two sons who died young and three daughters who did not. Fearing an old age and death without setting foot on French soil, she left her elderly husband in his riding school and set off to Paris via London in 1837, finally settling at 1 place St Louis in Versailles, facing the Cathedral.

2. Hill, *Julia Margaret Cameron*, p. 21.

3. Cameron, Woolf and Fry, *Julia Margaret Cameron*, p. 24.

4. *The Connoisseur*, vol. 72 (May–August 1925), p. 177.

5. William Dalrymple, *White Mughals* (London: Flamingo, 2003), p. xlvii.

Her daughters Julia, Adeline and Virginie all followed their parents into respectable colonial marriages, but took their mother's example and embraced travel, first to Versailles, then across the English Channel. Julia married East India Company employee Edward Impey in the autumn of 1813 and travelled to settle in his native England, in Kent, soon afterwards. Virginie married Samuel Beadle in Calcutta in 1822, moving to his native London shortly after to have their two sons, James and Ambrose. Adeline's choice of spouse, James Pattle, was also employed by the East India Company, but his alleged antics, both in life and after, became the stuff of legends.

If the Chevalier had been well known because of his talents, son-in-law James was known for less salubrious reasons. In memoirs of those colonial years in the early part of the twentieth century, Pattle became known as 'Jim Blazes' and remembered by some as 'as big a scamp as ever you saw, and a bad fellow in every way'.[6] Others were even less generous, feting him with the epithet 'The Biggest Liar in India'.[7] All of that is a far cry from the notice that appeared in *The Bengal Obituary*:

> The late James Pattle, Esq., Senior Member of the Board of Revenue, and the oldest in the Bengal Civil Service, died at his residence at Chowringhee, on Thursday 4th September, 1845, in the 69th year of his age. He had been suffering for a long period from a painful disease, which terminated in his death. He entered the civil service in the year 1790. In consequence of Mr Pattle's own earnest request his funeral did not take place here, but his remains were sent to England and deposited in the vault of his family in Camberwell. He lived respected and beloved.[8]

6. Smyth, *Impressions*, p. 476.
7. Nora Naish, *Passage from the Raj: Story of a Family 1770–1939* (Delhi: Champak Press, 2005), p. 17.
8. *The Bengal Obituary: Or, a Record to Perpetuate the Memory of Departed Worth, Being*

The fourth son of Thomas and Sara Pattle, of Kent, James was born into a family who had embraced the colonial way of life. Thomas Pattle grew to prominence in the Bengal Civil Service and combined decades in Calcutta and London, representing British interests in India. On returning to India he began a career as a judge in Murshidabad and Cawnpore, and worked for a while with William Makepeace Thackeray's grandfather, beginning a long and important link between the families.

James began his own career in 1792, aged seventeen, submitting a petition to the Court of Directors of the United East India Company with documentation from his school in Battersea. From his entry-level post as an assistant clerk he rose to becoming the third judge at Murshidabad, just as his father retired to return to London. In February 1811 he married Adeline, and within a year had become father to the first of the couple's ten children. Adeline Maria was born in 1812, followed by James Rocke Mitford Pattle in 1813, but the son did not survive the year. Eliza Ann Julia Pattle followed in 1814. The couple's fourth child, Julia Margaret Pattle, was born on 11 June 1815 in the Pattles' large Palladian mansion, called a 'garden house', in Garden Reach on the River Hooghly in Calcutta. Sara Monckton[9] Pattle followed in 1816. In the same year that Maria Theodosia was born, 1818, little Eliza was lost at sea during the family's journey to Indonesia. Louisa Colebrook Pattle followed in 1821. Then there was a pause until the birth of Virginia in 1827, Harriott Trevor Charlotte in 1828 and Sophia Ricketts Pattle, the final child, born in 1829. Harriott did not survive to her first birthday, so by the time of the completion of the Pattle family only seven daughters remained.

a Compilation of Tablets and Monumental Inscriptions from Various Parts of the Bengal and Agra Presidencies. To which is Added Biographical Sketches and Memoirs of Such as Have Preeminently Distinguished Themselves in the History of British India, Since the Formation of the European Settlement to the Present Time (London: Holmes & Co., 1851), p. 31.

9. Some of the Pattle girls owed their middle names to generals of the Pattle social circle, such as Robert Monckton (1726–1782) and William McBean George Colebrook (1787–1870).

It seems entirely likely that the 'painful disease' alluded to in James Pattle's respectful obituary was either alcoholism or a disease of the liver caused by it. His drinking led to infidelity and general bad behaviour which Pattle explained away as 'couldn't be helped' and Adeline in her besotted loyalty accepted, forgiving him repeatedly. In 1815 Pattle took a period of leave from the Company, taking his family on a health-giving sea voyage in an attempt to cure a serious liver complaint, probably caused by alcohol. The journey aboard the East India Company ship SS *Mornington* was less than relaxing, however, as it caught fire and ran aground. There was no loss of life, but the subsequent rescue of passengers was dangerous. The Company despatched a schooner to bring the Pattle family back to Calcutta, where Pattle returned to his court position at the beginning of the following year.[10]

Pattle was a prominent campaigner for regular steamships to travel between Bengal and England, possibly not specifically to remove his wife for convenient periods of time, but that was the upshot. Adeline took her girls to stay with their grandmother at Versailles, within sight of the palace that had been their grandfather's home. While James Pattle's family had chosen to educate their colonial son back in the motherland, the Pattle sisters were given over to their grandmother for their education.

It was on one of these journeys that the Pattle girls met William Makepeace Thackeray, at that time an art student, who dined with them in the autumn of 1833 and fell hopelessly in love with 'Pretty Theodosia'. When he met them again in 1839, Maria Theodosia Pattle had been married for two years to Dr John Jackson. The Pattle sister he fell in love with this time was Virginia, nicknamed 'Beauty' by the family. Whatever Thackeray wished, none of the Pattle girls was destined to be his wife, but although he did not fall in love with her, it was Julia's friendship that would last the rest of his life and beyond, through his daughter Anne.

10. Hill, *Julia Margaret Cameron*, pp. 35–36.

William Makepeace Thackeray (c. 1850) Frederic, Lord Leighton

James Pattle's drinking finally claimed his life in early September 1845 at his home in Chowringhee. To the surprise of his family, he had left very specific directions to have his remains transported back to England to be buried in the family vault at St Giles's Church in Camberwell, London. His body was preserved for the journey in a cask of alcohol, placed in an anteroom next to Mrs Pattle's bedroom, awaiting transportation. An often repeated gruesome tale of Pattle tribulations flowed from what followed. The grieving widow was awakened in the middle of the night by a tremendous explosion from the room containing her husband's body; on investigation the figure of James Pattle was discovered, standing bolt upright in the middle of the room. The shock was too much for Adeline, who suffered a breakdown and died a matter of weeks afterwards on the journey back to England. Pattle was once more placed in a barrel, in a boat down the Ganges destined for England. The sailors had

no idea what was in the barrel, and in due course began to tap the alcohol to drink. A slow leak finally caught fire and scuppered the boat just below Hooghly. Ethel Smyth recorded in her memoir: 'And what do you think the sailors said? – that Pattle had been such a scamp that the Devil wouldn't let him go out of India!'[11] With the death of her older sister Adeline Maria in 1836, the result was that after the death of both parents Julia Margaret had become the head of the Pattle household by the Christmas 1845.

11. Smyth, *Impressions that Remain*, p. 477.

CHAPTER TWO

Cupid and Psyche

JULIA, LIKE MOST COLONIAL CHILDREN, had not spent a great deal of her life in India. Her mother had taken her to Europe by 1818 and there she remained, being educated in the ways of an English wife. The exact details of the Pattle sisters' schooling are not known, nor indeed much about their life before their marriages. The only hint of the rather bohemian, unconventional upbringing Julia received is revealed in a comment she made about how she and her sister Sara 'used to wander forth and kneel and pray at the country roadside'.[1] Holidays were spent in Versailles with their grandmother, who had her own very exact ideas about what young ladies should learn. Mary Watts, writing in the memoir of her husband, the artist George Frederic Watts, and a close friend of Julia, revealed that Madame de l'Étang 'solved the problem of education for her granddaughters by having them taught all sorts of housewifely arts rather to the neglect of lesson books and accomplishments'. Not much has ever been recorded of the Pattle girls' time in France, but maybe a hint of it can be found, almost a century later, in the writing of Laura Troubridge, the granddaughter of Julia's sister Sara.

Laura, Lady Troubridge, wrote romances. *The Story of Leonora* (1930) takes as its inspiration a German poem, *Lenore*, which Julia herself had translated and published in 1847. In Troubridge's retelling, heroine Leonora is taken to live with a relative in

1. Melville, *Julia Margaret Cameron*, p. 4.

LEFT: *Madame de L'Étang* (no date) George Frederic Watts
RIGHT: Laura Troubridge and Alice Prinsep, daughter of Sara Prinsep

Versailles to be 'finished'. The briefly described experience of the young girl may have resulted from narratives told by the Pattle sisters to their children and grandchildren. The wonder of Paris charms young Leonora on the trips that she takes with Madame la Comtesse de Farrone, and as part of her education she is shown the art galleries and the Arc de Triomphe, which the Pattle girls might have viewed while it was under construction. Leonora is taught elegance and movement, how to cross a room and how to sit, 'tucking the feet well under the billowing skirts, so that only the top of two tiny shoes appeared, then to fold the hands and slowly turn the head in greeting'.[2] Troubridge leaves her readers in no doubt of her opinion of this training:

> It was to attract men who were supposed only to admire two types in women – the goddess and the fragile and

2. Troubridge, *The Story of Leonora*, p. 34.

feminine creature. The witty woman might claim their attention, but woe betide her if she showed the least sign of being that most odious of creatures, a blue-stocking. Equally the forward or fast girl was a woman they would run after and despise. Nothing then remained but to be beautiful, graceful and sufficiently charming and persuasive to get everything you wanted … It was therefore only natural that in the education of a young lady for society, accomplishments ranked higher in the programme than any solid attainments, and in the uncultivated mind all kinds of silly romances flourished apace.[3]

Clearly the purpose of this education was to study cooking and needlework and to develop an appropriate physical presence in order to be a good colonial wife and mother in time.

Alongside their grandmother, the sisters also had their aunts – Julia, Mrs Edward Impey, and Virginie, Mrs Samuel Beadle – to travel across the Channel with them and provide chaperones from eager suitors such as William Makepeace Thackeray.

By all accounts, a colonial daughter need not have feared stiff competition for a husband on her return to India. When Julia returned, aged nineteen, in 1834, she helped fill the perceived shortage of 'English' girls in society. At one gathering each lady had two gentlemen to escort her in, and matchmaking mothers could express an easy preference for the prospects and stability of a civil servant son-in-law over the glamour of a red-coated soldier match. However, the Indian climate was renowned for being detrimental to health, and much more, as Thomas Babington Macaulay – Lord Macaulay (on the Supreme Council of India) – complained in a letter to a friend: 'Steel rusts; razors lose their edge; thread decays; clothes fall to pieces; books moulder away, and drop out of their

3. ibid., pp. 34–35.

bindings; plaster cracks; timber rots; matting is in shreds.'[4] Julia's health was not good; she was prone to respiratory illness. In 1836 she found herself journeying to the Cape of Good Hope, South Africa, towards two men who would shape her life.

The astronomer John Herschel and his wife, Margaret, had travelled to the Cape in 1833. His father, Sir William Herschel, had been King George III's court astronomer and had discovered the planet Uranus through a telescope in his garden in Bath. Herschel continued his father's work, earning a knighthood in 1831, and completed the survey of the Northern Hemisphere. He then turned to his father's unfulfilled plans to map the southern skies, and installed a 21ft telescope in an observatory close to Table Mountain in a suburb of Cape Town in 1833. He had travelled to South Africa partly to escape the burden of being one of the most sought-after men of science in London. In the Cape the seclusion and the limited society enabled him and his wife to pursue their interests without pressure. Over the following four years this would include welcoming the return in October 1835 of Halley's Comet, long hunted for, and greeted with much enthusiasm and three exclamation marks.[5] In his diary for March 1835 Herschel records: 'Mr Trotter of the Bengal Civil Service called with an unintelligible Sanskrit paper from Prinsep',[6] which disturbed an otherwise peaceful Sunday of planting out Star-of-Bethlehem bulbs. The 'Prinsep' mentioned was James, architect and Orientalist, and contributor-cum-editor of the journal *Gleanings in Science*. His brother Thoby's marriage to Sara Pattle on 14 May of the same year possibly formed another mode of introduction for Julia when she arrived in 1836.

Charles Hay Cameron had also turned to the Cape in search of recuperation from the pressure of work. Born in 1795 and

4. G. O. Trevelyan, *Life and Letters of Lord Macaulay* (Frankfurt: Outlook Verlag, 2014), I, p. 316.
5. David S. Evans, *Herschel at the Cape: Diaries and Correspondence of Sir John Herschel 1834–38* (Rotterdam: A.A. Balkema, 1969), p. 195.
6. ibid., p. 148.

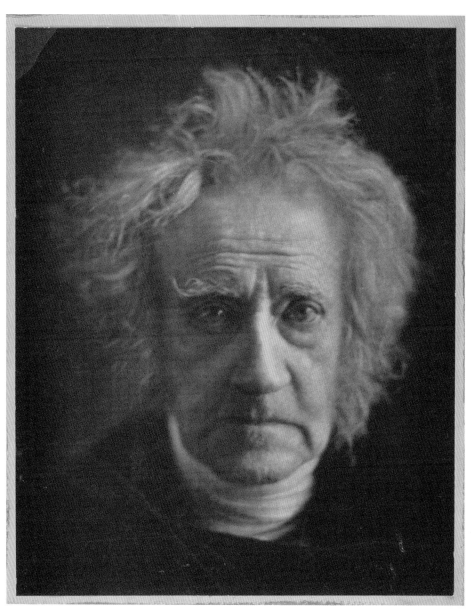

John Herschel (1875) Julia Margaret Cameron

Charles Hay Cameron (1864–65) Julia Margaret Cameron

Eton-educated, Cameron worked in Calcutta on the Indian Penal Code with Macaulay.[7] He had the impressive pedigree that made him an eligible match for Julia. His ancestors had stood on opposing sides in the Jacobite uprising. His maternal grandfather, James Boyd (later James Hay, 15th Earl of Erroll), pledged loyalty to the Hanoverians and fought at the Battle of Culloden on the opposite side to his father, William Boyd, 4th Earl of Kilmarnock, who was then executed. His paternal great-grandfather, Archibald Cameron of Lochiel, fought for the Young Pretender and was the last Jacobite leader to be executed.[8] Cameron's father, Donald, had come far from his treasonous roots to respectability as Commissioner of Malta and Governor of the Bahamas. According to Cameron's son Eugene, Cameron had been at school with Byron.[9] In February 1835 he had published an essay 'On the Sublime and Beautiful' and another 'On Duelling', which had previously appeared in the seventh edition of *The Westminster Review*. In preparation for his new colonial life in 1835, Cameron privately published the two essays in a slim volume. The preface of the book records that he was 'requested by a few intimate friends to print, for distribution among them and such others as feel an interest both in the subject and the writer'.

Herschel, Prinsep and Cameron became friends, exchanging views and books. In Herschel's 1837 diary, he records calling on 'Mr Cameron' on his way home from the observatory,[10] and having Miss Pattle to dine before he spent the night doing hourly observations of the sky 'which I carried on till 4AM of the 22nd when Margt

7. The Code was finally drafted in 1860 on the recommendations of the first Law Commission of India, established in 1834 under the Charter Act of 1833.
8. Charles Cameron erected a statue to his great-grandfather in the Savoy Chapel in London, where his remains were placed after his execution in 1753.
9. From the transcript of Margaret Hay Wodehouse's Journals, held in the Julia Margaret Cameron Museum, Dimbola Lodge, at Freshwater in the Isle of Wight, 9 May 1845.
10. Evans, *Herschel at the Cape*, p. 290.

The Duel Interrupted (after 1871) Herbert Bourne

[*sic*] relieved me and took the last two hours'.[11] Little else is known of Julia's life in South Africa and nothing of the medical treatment she received, if there was any, other than rest. Herschel, and his friendship with both Cameron and Julia, provides the only clue of the romance that occurred between the middle-aged romantic civil servant and the young enthusiastic woman with an interest in capturing beauty.

Julia had reason to thank Herschel for more than just the introduction to her future husband. As well as the man she loved, the eminent scientist introduced Julia to the subject that would become her all-consuming passion. Like many scientists working in the early decades of the nineteenth century, Herschel was fascinated by light, and from that by the use of lenses and the fixing of images so caught on paper by use of chemicals. He promoted the use of the word 'photography' to describe this new art – writing with light.[12]

11. ibid., p. 322.
12. John Hannavy, ed., *Encyclopedia of Late Nineteenth Century Photography* (London: Routledge, 2013), p. 654.

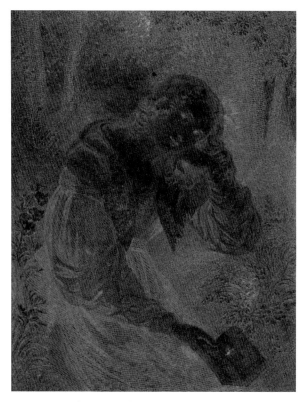

Engraved Portrait of a Young Woman (Cyanotype,
c. 1842) Sir John Frederick William Herschel

It seems most likely that it was from Herschel that Julia developed
her fascination with photography. She would go on to reward him
with some of the most iconic images of him. In Herschel Julia
found a father figure, an authority on a subject for which she had
unlimited enthusiasm once started. While the accepted legend of
Julia's life has her receiving a camera as a chance gift in her late
forties, from which she magically began a career, the likelihood is
that the seeds were sown and nurtured by Herschel, who continued
to correspond with her on the subject for the rest of their lives.

Once both the Camerons and the Herschels were back in England, Herschel welcomed Julia to his home in Collingwood where they explored the science of photography together, she for her art and he as a contribution to astronomy.[13]

For a woman of allegedly little education, Julia held her own in the company of the cream of Georgian intellect. Just as Herschel had translated *The Iliad,* Julia published *Leonora,* her own translation of Gottfried August Bürger's darkly Gothick *Lenore,* in 1847, after finding the versions by William Taylor of Norwich and Sir Walter Scott unsatisfactory. Writing in the preface to her version, she explained: 'Scott's translation is incomplete; and like Taylor's, its effect, whatever else it may be, is not that of the German poem.'[14] Ten years later, Julia still held these early days of their friendship dear to her heart: 'There is not a sweeter feeling in the soul I think than that of gratitude and I never can tell you how I cherish the remembrance of those friends who brightened my solitary life and cheered my time of trial when I was sick & desolate at the Cape…'[15] The feeling between the Camerons and the Herschels was apparently mutual, as the Herschels called their second daughter Julia, born in 1843, and Julia was a godparent.

Apart from Virginia and Sophia Pattle, the sisters were all married by the end of the 1830s. Sara married the charismatic civil servant Thoby Prinsep in 1835, and in the same year Maria married Dr John Jackson. Louisa married Henry Bayley in 1838. Henry would rise to become a judge in the Supreme Court in Calcutta. On 1 February of the same year, Julia married Charles Hay Cameron after the couple sailed back to Calcutta from the Cape.

13. Günther Buttmann, *The Shadow of the Telescope* (Cambridge: Lutterworth Press 1974), pp. 183–84.

14. Julia Margaret Cameron, *Leonora* (1847), p. vi.

15. Quoted in Ford, *Julia Margaret Cameron*, p. 17.

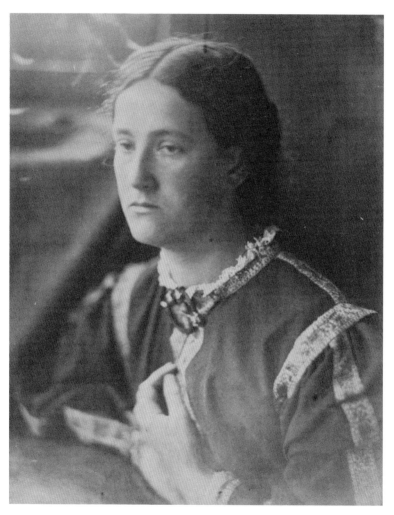

Julia Herschel (*c.* 1865) Julia Margaret Cameron

CHAPTER THREE

Kept in the Heart

THE CAMERONS LIVED IN CALCUTTA for a decade. The years of
domestic training enforced by Madame de l'Étang were given
an outlet in Julia's fierce devotion and pride in her husband. While
Cameron was generally well liked, others struggled a little to see
what she saw in him. To Scottish author Thomas Carlyle, Cameron
was a man with 'a sleek small red face, lively little black eyes and no
chin to speak of. Seems to be of Scottish breed or birth: May the
Heavens be good to him, poor little fellow!'[1] Years at Eton, London
and in the colonies appeared to have erased his Scottish ancestry
to all but the most determined viewer. Cameron had been called
to the Bar in England, but found his talents diverted to Ceylon
to investigate judicial procedure, publishing an official report in
1832. By that time, he was in love with Ceylon, and the loosening
of foreign ownership restrictions gave Cameron the opportunity
to purchase land. He bought substantial coffee estates there in the
form of a plantation near Dimbola (sometimes spelt Dimbula or
Dimboola) in the Dikoya Valley and other smaller estates. Another,
called Rathoongodde, was added to the family's holding in the
1870s.[2] The newspapers were in no doubt of the importance of
coffee to the island: 'what matrimony is to the mother of a family
and the endowed church to the country clergyman – that coffee is to

1. Quoted in Hill, p. 45.
2. Jeff Rosen, *Julia Margaret Cameron's 'fancy subjects': Photographic allegories of Victorian
identity and empire* (Manchester: Manchester University Press, 2016), p. 269.

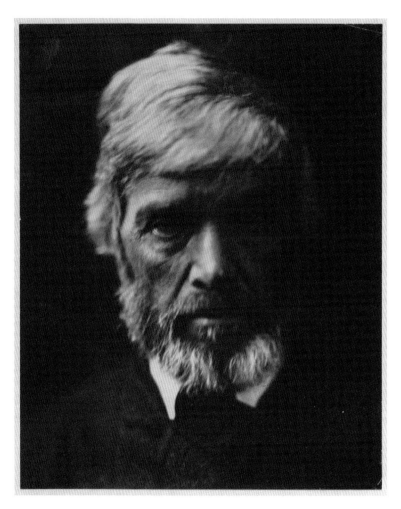

Thomas Carlyle (1867) Julia Margaret Cameron

Ceylon.'[3] The Dutch had begun growing coffee on the island by the middle of the seventeenth century, and despite the fact that coffee prices had been low after a glut and crisis in the market in 1823, the growth in coffee drinking among the working classes both in Europe and in North America made it a brisk industry with room for growth, especially if one was utterly besotted with the place.[4] It was estimated that the plantations Cameron purchased made him the largest private landowner on the island. One extensive area became known as 'Cameron's Land'.

Cameron developed a reformer's zeal, believing that Western law and education would transform the lives of the islanders, creating 'liberty', a desire that betrayed his Enlightenment-era education. His 1833 Ceylon Charter of Justice was the written expression of this desire. In the same year, Cameron sat on the committee of the Society for the Diffusion of Useful Knowledge, and eventually rose to President of the Council of Education for Bengal. His altruism was markedly colonial. His vision of education for the Ceylonese was in accordance with British standards, and the language of higher education was English rather than that of the native population he wished to liberate.

Their first child, a daughter named Julia Hay Cameron – Julia for her mother and Hay for her paternal grandmother, Lady Margaret Hay – and nicknamed 'Juley', was born ten months after the Camerons' marriage, in December 1838. The years that followed brought Eugene Hay and Ewen Wrottesley Hay, born in 1840 and 1843 respectively, but in accordance with colonial custom Julia did not have much time with her children, who were shipped back to England for their education and health. By the time his wife was pregnant with Ewen, Cameron had been appointed the first legal member of the Council of India, and as none of the governors

3. *The Northern Whig*, Belfast, 7 August 1875.
4. Mark Pendergrast, *Uncommon Grounds: The History of Coffee and How It Transformed our World* (New York: Basic Books, 1999), pp. 7, 47–48.

general until 1848 was married or had his life in India, Julia fulfilled the role of 'First Lady' of the colony.

In an early letter to family friend Major George Broadfoot, whom she calls 'an intellectual Hercules', Julia entreats him not to sacrifice himself to his zeal to promote the public good: 'I (although a woman) am a lover of public good, and still maintain that useful good men, being rare, ought to bear in mind how precious they are.'[5] She likewise felt that her beloved husband was being held in Calcutta for the good of others, his intellect used without actually being listened to. The heat was driving her thoughts back to her children in England. Cameron did not suffer the heat well as it interfered with his work, so Julia was often sent to social events alone. Attending a ball could well render the next day unworkable, as recovery was needed from the heat and exertion; for the industrious Cameron, that was unthinkable.

On his journey back to England, Eugene, a baby, was taken ill, and still marked by the death of her sister and mother at sea, Julia was frantic with concern until word was brought to her that he had recovered and was the pet of the crew.[6] Juley and Eugene were sent to live with Cameron's widowed sister Margaret Hay Wodehouse, who had returned from Nova Scotia after the death of her husband, a vice-admiral in the Royal Navy, to set up house in Broadwater, West Sussex. Aunt Margaret Hay kept a journal of her time with her brother's children, which probably echoes the lives of colonial children in their parents' era, if not before. Juley was fond of her aunt, who she declared to be much like her father. The children missed their parents desperately, often mixed with a longing for Calcutta itself, so different from the south coast of England. At the height of summer in 1845, Aunt Margaret noted, Juley dismissed the heat as being 'exactly like the winter in Calcutta', adding: 'If I was

5. W. Broadfoot, *The Career of Major George Broadfoot CB* (London: John Murray, 1888), p. 200.

6. Melville, *Julia Margaret Cameron*, p. 14.

a bird I would fly to Calcutta! Will not Sir Henry Hardinge allow Papa to leave his Council and come home?' Letters from Calcutta were as eagerly embraced as if they were the people themselves, and sometimes they foretold a visit from family. In October 1845, at the news of her mother Julia and baby brother Ewen's imminent arrival from India, Juley exclaimed: 'I wish Papa would be naughty so Sir Henry Hardinge would put him out of the Council and he would come home too.' The distance was a trial, but also a blessing when the most desperate times for the Pattle family occurred. Although the children expressed joy at the thought that their grandmother Adeline and young aunts would be arriving back in England to bring home the body of James Pattle, at the news of the subsequent death of his grandmother young Eugene, 'with a most sorrowful face said, "You know I do not remember her."'

Julia did not spare her children the harrowing facts of life in the colonies. In January 1846 she wrote of a bloody battle in the Anglo-Sikh war in a letter to seven-year-old Juley; their aunt recorded that 'She and Eugene listened to it in breathless attention and a few tears stole down Juley's cheek, while Eugene silently laid his head on my arm and hid his face. "And will not my Papa go to counsel Sir Henry Hardinge?"'[7]

The loss of Juley overseas was the most difficult blow for Julia to deal with. While comforting herself that her daughter was enjoying the health-giving rolling hills of the English countryside, the longing for her children made Julia ill. In response, Cameron became his wife's secretary, taking responsibility for part of her correspondence to spare her from repeating news that tested her nerves. She plunged her considerable energy into charity work, mirroring her husband's work for the greater good, raising an impressive £14,000 for the Irish Famine relief fund, a concern that would later echo

7. ibid.; Margaret Hay Wodehouse, Journal (cit. above, p. 17 n. 9), 12 June and 22 August 1845, 3 October 1845, 8 May 1845, 28 December 1845, and 24 February 1846.

in her art. The fortitude she displayed not only in the separation from her children but also when she was faced with the malicious scandal that greeted the death of her father and mother seemed to enhance her in the opinion of others. The redoubtable, determined qualities displayed by Julia and her sisters in the face of their father's behaviour and tragicomic afterlife caused Lord Dalhousie to state that mankind was divided into men, women and Pattles.[8]

Julia would have to wait three years before realising her dream of reuniting with her children in England. In 1848 Charles Cameron finally bowed to the pressure of his wife and retired from colonial service, and the Camerons embarked for England where Charles dreamed of devoting his life to Classical studies, funded by the proceeds of his coffee estates, and Julia could be united once more with her children and her sisters Sara, Virginia, Sophia, Maria and Louisa.

8. Liddell, *Notes from the Life of an Ordinary Mortal*, p. 85.

CHAPTER FOUR

Sister Spirits

THE ENGLAND TO WHICH THE CAMERONS were returning was changing very purposefully from the instability and war of Georgian England to a country ruled by a young monarch with her own ideas. Queen Victoria had ascended the throne in 1837, heralding a new era of society, one that would be defined by family and invention. The year that brought the two youngest Pattle girls back to England with the bodies of their parents, 1845, also saw the lifting of the tax on glass, leading to a boom in conservatories and orangeries. The Pattle sisters were not the only exotic imports: there was also a growing interest in plants from all corners of the world. Long sea voyages for the foreign blooms needed care: 'Glass was used to make the Ward's box, an easily transportable and sealed box that housed plants in the necessary microclimate to survive long sea voyages. Taken to a larger scale, exotic plants in new climates needed hothouses and conservatories.'[1] The lifting of the tax would also prove advantageous to any photographer seeking a 'glass house' for their art.

It was usual to rent rather than buy a property in London,[2] with costs running from £5 per year for a single room to £50 for something more palatial. Fitted carpets were unthinkable, leading

1. Caren Yglesias, *The Innovative Use of Materials in Architecture and Landscape Architecture* (Jefferson, N.C.: McFarland, 2014), p. 82.
2. Liza Picard, *Victorian London: The Life of a City 1840–1870* (London: Weidenfeld & Nicolson, 2005), p. 50.

to a fashion for rugs from Turkey and the Orient. Servants were another essential for your respectable household. In 1840 an annual income of £150 would cover your household expenses and a single servant. If your maid lived out, that would cost £3 per year; a residential maid cost three times as much. And there was the cost of feeding them: as one woman declared, faced with the bill for her daughter's two maids, 'it's not their wages – it's their food!'[3]

Into London society in 1843 arrived the first of the Pattle sisters. Sara and Thoby Prinsep with their Bengal-born sons Valentine, Arthur and Henry returned from India and rented a house in Chesterfield Street, Mayfair, recently vacated by Beau Brummel.[4] By the time of the birth of Alice Maria Prinsep in 1844 the family had moved to 87 Hyde Park Gardens, and Virginia was born there in 1848. However, ably demonstrating the mobile nature of society in this period, by the time of little Virginia's death, just twenty-two months later, the Prinseps were living in Great Cumberland Place, north of Mayfair. It was here that Sara's younger sister Maria, or 'Mia' as she was known to the family, came from India with her daughter Julia, because of her health

Alice Prinsep (*c*. 1850) George Frederic Watts

and presumably that of her child. Her husband, Dr John Jackson, joined them after his retirement in the mid-1850s.

Sara wrote to her sister Julia extolling the pleasures of London society, but Julia was scathing of the shallowness of a life of

3. Lucy Lethbridge, *Servants: A Downstairs View of Britain from the Nineteenth Century to Modern Times* (New York: W. W. Norton & Co., 2013), p. 17.

4. Beau Brummel lived at 4 Chesterfield Street from 1778 to 1840.

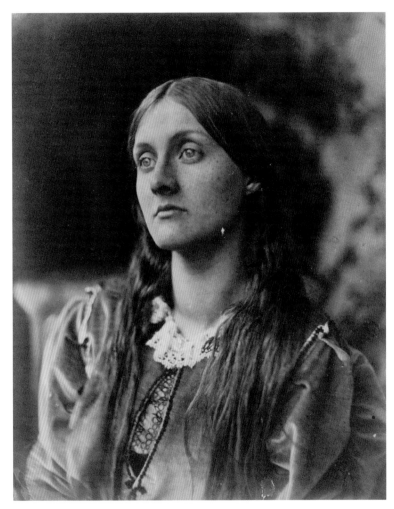

Julia Jackson (1867) Julia Margaret Cameron

socialising. It is possibly for this reason that when the Camerons returned in 1848 they did not choose to live with the Prinseps, but instead became the neighbours of fellow ex-colonial civil servant and poet Henry Taylor, in Royal Tunbridge Wells, Kent. Taylor had been an administrator in the Colonial Office in Calcutta and had found Charles Hay Cameron exceptionally good company, describing him as 'an accomplished Scholar and Gentleman of great literary and general knowledge and his writings are in grace, force and clearness of diction, superior to almost any of his time'.[5] Any man who admired her husband was sure to become a favourite of Julia's, especially if that man was a writer himself and one who had flatteringly described Julia as the queen of European society in Calcutta.[6]

This is not to say that the Pattle sisters did not become closer than ever. Wilfrid Blunt, biographer of the artist G. F. Watts, remarked that 'the seven Pattle Sisters' sounded like a circus act 'and there was indeed something rather theatrical about these

5. Melville, *Julia Margaret Cameron*, pp. 9–10.

6. ibid., p. 13.

Anne Thackeray (May 1870) Julia Margaret Cameron

remarkable young women'.[7] Certainly in the minds of those who saw the 'holy sisterhood', as they became known, there was much to admire. Anne Thackeray – daughter of William Makepeace Thackeray (Mrs Richmond Ritchie after 1877) – wrote: 'They were unconscious artists with unconventional rules for life which excellently suited themselves.'[8] Sara was known for her hospitality and salons, Virginia for her beauty, Julia for her intellect and spirit, Sophia for her sweetness, and Maria for a blend of these virtues. To Lady Somerset, a family acquaintance, Sara, Julia and Virginia were a blend of the finest qualities of their parents, carefully balancing the looks and goodness of their mother with the charisma and intelligence of their father. It was perhaps Lady Somerset who gave the sisters nicknames: Virginia was 'Beauty' for her charms, Sara 'Dash' for her striking social impact, and Julia 'Talent' for her intellect and application.

This has left many biographers with the impression that Julia was unattractive, and indeed she did not seem to value her appearance, especially in old age. Sidney Colvin in his memoir fondly recalls her when he met her as a young man: 'With her untidy wisps of grizzling hair and her fingers stained brown with photographic chemicals, this lady presented nothing very attractive to the eye, but her resources of mind and character made themselves felt not less strikingly in her talk than in her work.'[9] An unnamed model, writing as a 'Lady Amateur' in the *Photographic News* in 1886, described her first impressions of the photographer: 'a short, stout elderly lady, not handsome in features' – but, she went on to say, 'she had, I believe been considered a beauty in her youth'.[10] It might be fairer to say that in comparison with her sisters she was

7. Wilfrid Blunt, *England's Michelangelo': A Biography of George Frederick Watts* (London: Columbus Books, 1989), p. 69.

8. Ritchie, *From Friend to Friend*, p. 3.

9. Sidney Colvin, *Memories and Notes of Persons and Places* (New York: Scribner, 1922), p. 94.

10. *Photographic News*, 1 January 1886, p. 3.

not the star. Possibly also her intellect and the value she placed upon that in others gave her the reputation for 'talent'. Anne Thackeray noted: 'A friend of mine told me how on one occasion she accompanied her [bareheaded], carrying a cup of tea which she stirred as she walked along.'[11] The other Pattle girls were marked out by their 'otherness' in dress, action and even language as a species of their own. Among themselves the sisters conversed in Hindustani, and they were known to fashion their own clothes from Indian fabrics which they would unpick and resew into new garments. It is possibly a comment on the merits of all the sisters that despite flouting or ignoring the rules of the society they had descended upon, they were regarded as fascinating rather than appalling.

When Sophia married Sir John Warrender Dalrymple in 1847 it left only Virginia unmarried, not that she was short of suitors or offers. At one ball she attended sixteen proposals were offered, all refused. William Makepeace Thackeray wrote an essay in *Punch* on her beauty, entitled 'On a Good-Looking Young Lady', under the humorous pen name 'Dr Solomon Pacifico'. In it he extolls the wonders of a girl called Erminia: 'her face is a personal kindness for which one ought to be thankful to fortune … When she comes into the room, it is like a beautiful air of MOZART breaking upon you.'[12] However, Virginia was frustrated that all that was seen was her beauty. In *Punch* Thackeray related an occasion, based on fact, when after receiving numerous love poems Erminia started to cry: 'The verses of course were full of praise of her beauty. "They all tell me that," she said; "nobody cares for anything but that."'[13]

Watts heard of Virginia's astounding beauty from a friend who extolled the virtues of the beautiful Miss Pattle of Chesterfield Street. Watts's morning walk took him to Chesterfield Street to seek out this vision. There he saw a beautiful young woman,

11. Ritchie, *From Friend to Friend*, p. 4.
12. *Punch*, vol. 18 (1850), p. 223.
13. ibid., based on Virginia's reaction to a piece written by Henry Taylor.

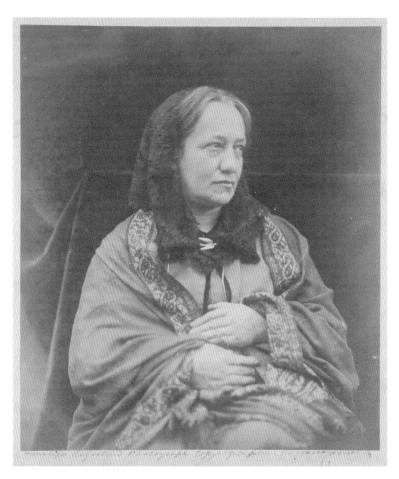

Julia Margaret Cameron (1870) Henry Herschel Hay Cameron

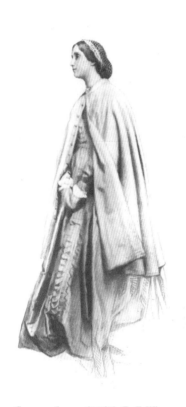

Countess Somers (1849) G. F. Watts

'her long grey cloak falling in beautiful lines against her tall figure',[14] and immediately sought her acquaintance as a model. In accordance with propriety, Virginia took her sister Sara with her to the sittings, which were numerous and produced many sketches. One study was so small that Julia carried it around in her watch case. The oil painting that Watts exhibited of Virginia at the Royal Academy in 1849 shows her in artistic dress as created and worn by the Pattle sisterhood. The dove-grey cloak that had so captured the artist's imagination is present, as her elegant figure pauses on the top of stairs that would take her to the next part of her life. It was a common symbol in Victorian art, in works such as *The Golden Stairs* (1880) by Edward Burne-Jones. It is notable that the stairs descend rather than ascend, hinting that Watts found his model to be a heavenly pinnacle of perfection and that anything that followed would be a downward step. Lord Aberdare exclaimed: 'Oh, how in love with her we all were!' and Sir Charles Newton reminisced how 'deeply grieved' men of his circle were when she married, as 'we thought she ought not to marry any *one*'.[15]

As it was, Watts was the cause of her marriage. In a story treasured for its romance, Viscount Eastnor, later Lord Somers, was visiting the Royal Academy exhibition at Burlington House and

14. Watts, *George Frederick Watts*, I, p. 122.
15. ibid., pp. 125–26.

saw the portrait of Virginia. He exclaimed aloud 'I must know that woman!' and sought her out. Another possible, if less romantic, reason for the meeting is offered by Mary Watts in her biography of her artist husband. Watts had been ill, and after a prolonged stay with Lord and Lady Holland in Italy his ill health returned. Mary Watts writes, 'This, of course, appealed to the large mother-heart of Mrs Prinsep', and when Watts was taken ill at Eastnor Castle

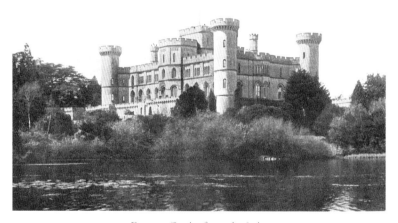

Eastnor Castle, from the Lake

in Herefordshire in the early months of 1850, Sara and Virginia took a carriage to fetch him, introducing the sisters to the love-struck Viscount. Whichever version of the story is true, the couple married in October of the same year. Once in Sara's sphere of care, Watts was unable, or perhaps more accurately unwilling, to leave. 'He came to stay three days, he stayed thirty years', Sara is reported to have told Mary Watts.[16] He was the conduit that brought Sara Prinsep and her husband to settle in Little Holland House, in

16. ibid., p. 128.

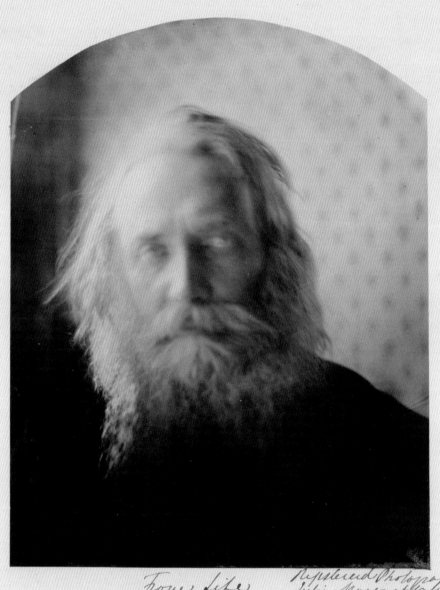

From Life
Henry Taylor
Author of Philip Van Artevelde

Registered Photograph
Julia Margaret Cameron

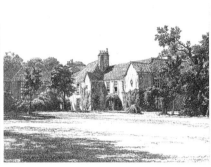

Old Little Holland House from the South West (LEFT)
and the North East (RIGHT)

the shadow of Lord Holland's home in Kensington. Julia kept a slight distance by Pattle standards from these societal moves by her sisters, but the relationships formed by Sara and Virginia at the turn of the decade would affect Julia and her maid, Mary Hillier, in the years to come.

The Camerons' move to Tunbridge Wells enabled Julia to develop her own social circle. Charles Tennyson, grandson of the poet laureate, described her as 'a woman of volcanic energy with a romantic passion for the arts and an immense capacity for hero-worship'[17] – which she applied to Henry Taylor. She called him 'Philip' after the hero of his most famous work, *Philip van Artevelde* (1834), and was ferociously protective of his 'genius'. William Allingham's diary records how he wavered on the point of Taylor's greatness in a conversation with Julia and found a proffered present of a copy of Taylor's works withheld. For Julia to withhold a present was very serious indeed, as she was exceptionally generous to those she loved. The Taylors were showered with many expensive gifts, including the complete redecoration of one of their rooms. When staying at their home one night, Julia transformed a

17. Charles Tennyson, *Alfred Tennyson* (London: Macmillan, 1949), p. 323.

OPPOSITE: *Henry Taylor, author of Philip Van Artevelde* (1864)
Julia Margaret Cameron

55

room, 'elegantly furnished in light coloured wood', by means of *decalcomania*, strips of coloured paper and designs 'of an inferior kind' transferred on to wood or china. The Taylors were roused the next morning by an excited Julia, who presented them with her work with evident pride. Whether the Taylors were pleased with her handiwork or not is discreetly left unrecorded.[18]

Luckily, the Taylors felt the same about the Camerons. When the Taylors moved to Mortlake, a suburb of London, Julia convinced her husband to take Percy Lodge in East Sheen, not far from them.

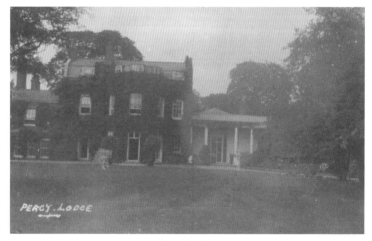

Percy Lodge

It was at the Taylors' house on 21 October 1850 that Julia met Alfred and Emily Tennyson. The couple had married in June of that year. His poem *In Memoriam* was published around the same time, and just over a month after the meeting Tennyson became Poet Laureate on the death of Wordsworth. The relationship between Taylor and Tennyson was not an easy one: Tennyson felt intimidated by the older man, and Taylor patronised Tennyson. They had been

18. Liddell, *Notes from the Life of an Ordinary Mortal*, pp. 5–6.

rivals for the laureateship, but as time passed they grew closer. Julia embraced the excitement of Emily Tennyson's pregnancy, writing almost continuously to find news of her progress and health. Julia swiftly fetched medical help when Emily went into labour, ensuring the safe delivery of the couple's longed-for first child. "'Never till the hour of my death," Tennyson said, would he forget her "'great kindness … in the hour of my trouble,'" joining the two families together for the rest of their lives.[19] By her friendships with literary men Julia eased into the social scene that Sara enjoyed and which she had previously scorned. This was increased by her renewed friendship with Thackeray, since disastrously married, and his two daughters, Anne Isabella (also known as Anny) and Harriet Marian (known as Minnie).

Their return to England reunited Charles and Julia Cameron with John and Margaret Herschel. Julia had been godmother to one of the Herschels' children, and she asked Herschel to be godfather to her son Henry Herschel Hay Cameron, born in 1852. Through Sara's salons in Little Holland House Julia made the acquaintance of many new friends and future subjects. Among the artists who attended Watts there, the Pre-Raphaelites William Holman Hunt and Dante Gabriel Rossetti found an enthusiastic admirer in Julia, but she only managed to convince Hunt to pose for her photographs in later life, and gained sittings with Rossetti's brother and sister instead of the painter poet himself.

Henry Herschel Hay Cameron (1867)
Julia Margaret Cameron

19. Ann Thwaite, *Emily Tennyson: The Poet's Wife* (London: Faber & Faber, 1996), p. 248.

William Michael Rossetti (1865) Julia Margaret Cameron

Julia Margaret Cameron (1850–52)
G. F. Watts

Watts would be one of the few who treated Julia with respect as a fellow artist. He painted her portrait in 1850–52, along with those of her sisters, and he gave a copy of his portrait of Virginia to Julia. This she repaid with copies of her photographs, presenting him with an album of her early works, shortly after beginning on her career. Dated 22 February 1864, just two days after Watts's marriage to the actress Ellen Terry, it may have been partly intended as a wedding present, but the inscription celebrated him in Julia's usual florid tone: 'To The Signor to whose generosity I own the choicest fruits of his Immortal Genius. I offer these my

first successes in my mortal but yet *divine*! art of photography.'[20] Their bond over art was to last far longer than the painter's ill-fated marriage to the young Ellen Terry. Julia even managed to capture a handful of images of the young actress during her unhappy honeymoon in Freshwater where Julia by then was living. Ellen Terry was only married to Watts briefly. Through her attachment to Watts Julia received the validation she craved as an artist, not to mention the approval of one of her heroes.

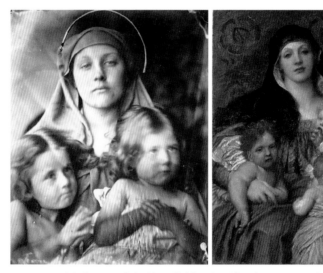

LEFT: *Madonna and the Two Children* (1864) Julia Margaret Cameron
RIGHT: *Charity* (1898) G. F. Watts

Watts in turn found inspiration in Julia's photographs. His 1898 painting *Charity* bears more than a passing resemblance to Julia's *Madonna and the Two Children* (1864). One of many showing Mary as the Virgin Mother, Julia's treatment of the subject in this particular image, a print of which was given to Watts, is remarkable for the halo she scratched on the negative, visible in

20. Cox and Ford, *Julia Margaret Cameron: The Complete Photographs*, p. 503.

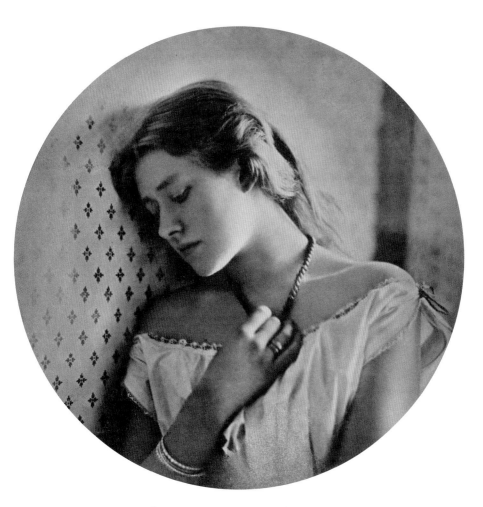

Ellen Terry at age Sixteen or *Sadness* (1864)
Julia Margaret Cameron

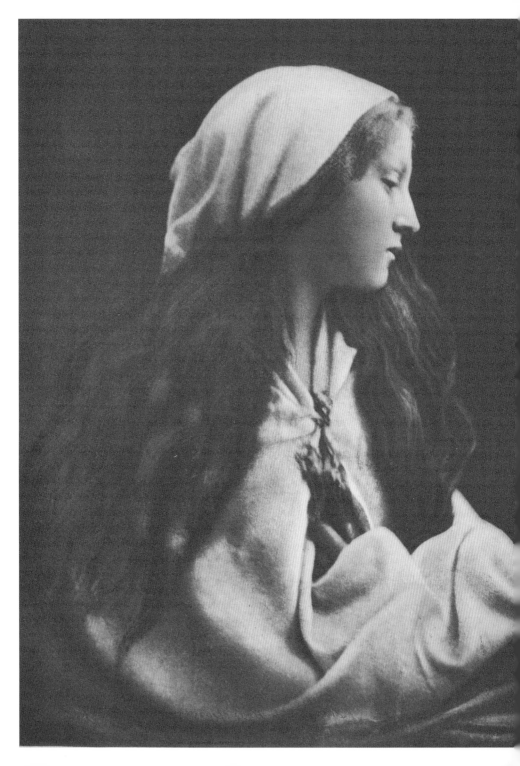

the developed print. Throughout Julia's photographic career, and particularly in its infancy, Watts provided encouragement and guidance that she respected, coming from an artist she admired and in some ways endeavoured to emulate. His letter in response to a group of proffered photographs balances praise with entreaties to strive for more: 'All the heads are divine and the plates very nearly perfect; the tone too is excellent … But you must not be satisfied; there is more to be done, and whilst this is the case we must never think anything done. I know your difficulties, but the greatest things have been done under difficulties.'[21]

Julia was immensely proud of her connection with and praise from the illustrious Watts, and encouraged him to write his praise directly on the photographs for which he felt so strongly. Under the photograph entitled *The Dream* (1869)[22] he wrote 'Quite Divine – G. F. Watts'. However, when the artist could not be convinced to do so she was not above forging his signature.[23]

21. Quoted in Watts, *George Frederick Watts*, pp. 207–8.
22. Also known as *The Day Dream*.
23. Hinton, *Immortal Faces*, p. 44.

OPPOSITE: *The Dream* (1869) Julia Margaret Cameron

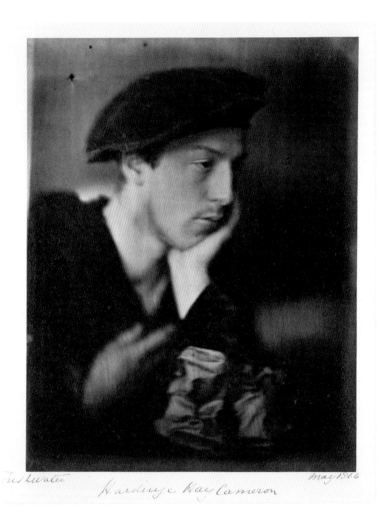

Hardinge Hay Cameron (May 1864)
Julia Margaret Cameron

Lilies and Pearls

WHEN THE CAMERONS MOVED AGAIN it was not far. They rented Ashburton Cottage on Putney Heath on 20 May 1857. Julia's nest was emptying; the two elder sons, Eugene and Ewen, had finished school and were ready for adult life. Juley married Charles Norman on 18 January 1859, and Hardinge, born in 1846, was away at school in Charterhouse. Julia kept her remaining two sons, Charles, born in 1849, and Henry Herschel, born in 1852, at home, where a tutor taught them before they too advanced to Charterhouse.

Also in 1859, Julia was walking on the Heath when she came across a woman begging with her ten-year-old daughter. She was an Irish immigrant, Johanna Ryan, with her daughter Mary. Having raised money in India for the relief of the Irish Famine, Julia took the plight of the Ryans to heart. She took Mary in to her home to be trained as a servant and found work for Mrs Ryan. By the end of the year, however, upheaval threatened the Cameron home. Charles Cameron's investment in his plantation was thriving, drawing him back to visit Ceylon,

Charles Norman (1874)
Julia Margaret Cameron)

Ewen Hay Cameron (25 November 1869) Julia Margaret Cameron

taking Eugene and Ewen with him. The thought of her husband's absence and the long sea journey that lay ahead for them made Julia ill with worry. She wrote in anguish that her beloved husband was leaving 'to his wild woods & favourite forests & seductive Estates of Ceylon & he has taken my two eldest boys Eugene & Ewen with him'. Julia's opinion of Ceylon was less than glowing. She would remain with the younger boys, not to mention the imminent arrival of Juley's first baby: 'Charles speaks to me of the flower of the coffee plant. I tell him that the eyes of the first grandchild should be more beautiful than any flower.'[1] Coupled with this, her husband's health, always slightly precarious, was not at its best and however rejuvenating Cameron claimed Ceylon to be, the journey might well have killed him. To soothe her nerves, Alfred Tennyson, who had come to see Cameron off on his travels, took Julia and her three youngest sons home to the Isle of Wight, between the Solent and the Channel, off the Hampshire coast, where

Alfred Tennyson (4 July 1866)
Julia Margaret Cameron

he had purchased a home, Farringford, away from the prying 'Cockneys' whose hero worship of the new Laureate was not tolerated by the poet. The public nature of his work troubled him, as demonstrated by an outburst one evening at dinner recorded by Henry Taylor:

1. Cameron, Woolf and Fry, *Julia Margaret Cameron*, p. 38. Charles Cameron named a waterfall on his estate after Juley's baby, Charlotte, on hearing the news of her birth.

> He was very violent … on the subject of the rage for autographs. He said he believed every crime and every vice in the world was connected with the passion for autographs and anecdotes and records; that the desiring anecdotes and acquaintance with the lives of great men was treating them like pigs, to be ripped open for the public; that he knew he himself should be ripped open like a pig; that he thanked God Almighty with his whole heart and soul that he knew nothing and that the world knew nothing of Shakespeare but his writings; and that he thanked God Almighty that he knew nothing of Jane Austen, and there were no letters preserved either of Shakespeare's or of Jane Austen's; that they had not been ripped open like pigs.[2]

For Julia, who had never needed to be in society to feel close to the men and women for whom she felt affection, the island with its promised seclusion was a revelation, one which would change her life.

2. Taylor, *Autobiography*, p. 193.

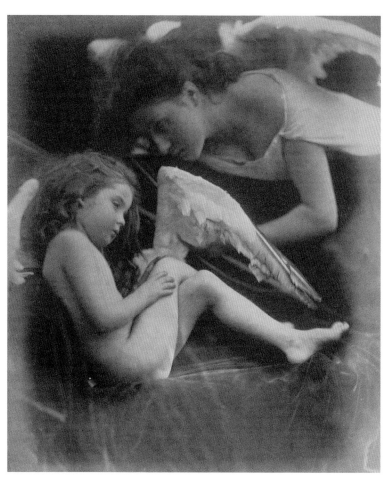

Venus Chiding Cupid and Removing His Wings (1869)
Julia Margaret Cameron

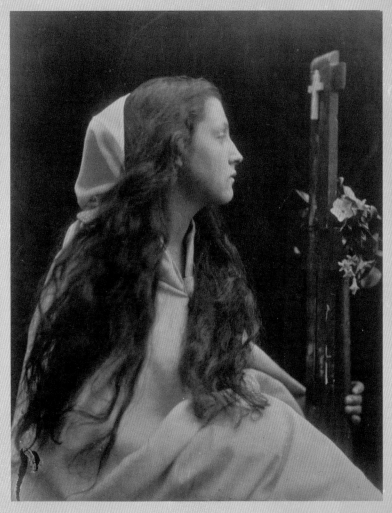

Lady with a Crucifix (1869)
Julia Margaret Cameron

Julia and Mary

THE MODEL, IMPATIENT BUT GOOD humoured, has already been placed in position in order to establish the shot before the plate is sensitised. Now you must work quickly, and the wooden plate holder is slipped into the back of the camera. A cap is placed over the lens at the front. The dark slide is taken from the plate holder, and when ready the cap is removed from the lens. After a minute (or for however long the exposure is to be) the lens cap is replaced and the dark slide slid back in to seal the plate holder. The box is removed and taken down to the darkroom immediately.

The plate is removed from the holder and held sensitive side up. Developer is quickly poured over, and the image magically appears. A simple-sounding procedure, but in reality you have to pour a medicine cup of the liquid down one edge quickly and evenly while tilting the plate in semi-darkness. Then the washing begins. Jugs of water are poured over the plate, after which it is immersed in a bath of water, then another bath of developing fluid, after which it is safe to turn on the light. The plate is then washed again and finally left to dry on a rack.

When the plate is dry, varnish can be poured over (much as the collodion is poured) and the image left near strong heat to dry, such as a spirit lamp – risky when everything is so flammable.

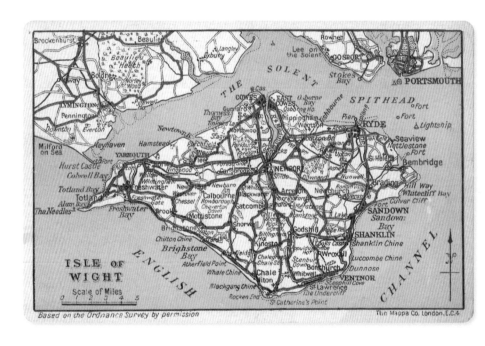

Brockenhurst · Beaulieu · Langley · Rower · Lee on the Solent · GOSPORT
Beaulieu Heath · Exbury · THE SOLENT · Stokes Bay · PORTSMOUTH
Pitway · Boldre · Norley Wood · SPITHEAD · Fort · Fort · Lightship
LYMINGTON · Pennington · Pylewell Hor. · Cas · EAST COWES · Osborne Bay · Osborne Ho · Pier · RYDE
Downton · Everton · COWES · Gurnard · Whippingham · Wootton · Abbot · Oakfield · Seaview
Milford on Sea · Keyhaven · Thorness Bay · Thornessla · Northwood · Whitefield · Nettlestone Fort
Hurst Castle · Yarmouth · Hamstead · Stag · Birchfield · Newtown · Parkhurst · Forest · Rocks · Upton · St Helens · Bembridge
Colwell Bay · Shalfleet · Carisbrook · NEWPORT · Staplers · Ashe · Hill Way
Totland Bay · Wilmingham · Ringwood · Forestside · Shide · Gilward · Nunwell · Brading · Whitecliff Bay
Alum Bay · Freshwater · Newbridge · Newbarn · Blackwater · Arreton · Newchurch · Alverstone · Culver Cliff
The Needles · Freshwater Bay · Freshwater Gate · Westover · Calbourne · Rowborough · Godshill · Merstone · Lake · SANDOWN · Sandown Bay
Brook · Chessel · Cheverton Down · Gatcombe · Blandford · Cranstone · SHANKLIN
Brighstone Ho · Mottistone · Snowell · Billingham Ho · Godshill · Rookley · Cook's Castle · Shanklin Chine
Chilton Chine · Chilton · Whitefield · Kingston · Apuldurcombe · Luccombe Chine
Brighstone Bay · Atherfield Point · Chale Fields · Chale St · Stenbury Down · Wroxall · Dunnose
Whale Chine · Rocken End · Chale Niton · Whitwell · Bonchurch · VENTNOR · Steephill Cove
Blackgang Chine · St Lawrence · The Undercliff
St Catherine's Point

ISLE OF WIGHT

Scale of Miles
0 1 2 3 4 5

ENGLISH · CHANNEL

Based on the Ordnance Survey by permission · The Mappa Co. London, E.C.4

CHAPTER SIX

Three Fishers went Sailing into the Deep

ACCORDING TO THE *Saturday Magazine*'s article in 1834, the western extremity of the Isle of Wight was anciently styled the Isle of Freshwater. The Western Yar rises close to the beach on the south and flows out at Yarmouth on the northern coast, almost separating this corner from the rest. This island within an island was praised for its scenery, the cliffs and the prodigious number of seabirds that attracted crowds of islanders in search of down and eggs. Desperate for their spoils, they risked life and limb by dangling on ropes over the romantic splendour of the cliffs, then hunted the marine grottoes of the many caves, with their mantles of moss and seaweed. The washing of the smooth pebble beach with each returning tide rendered the freshness of that delightful retreat an escape from hot weather and a wonderland for the curious traveller.[1]

Tennyson was not the first poet to cross the Solent, and it was that very fact that had lured him to the Wight. In the spring of 1816 John Keats sought a home outside London. He had been considering this point for a number of months but he had not settled on a location: 'Margate was a possibility, but when [Charles Wentworth] Dilke suggested the Isle of Wight, it seemed preferable, more truly removed, a kind of readymade bower.'[2] For Tennyson,

1. *Saturday Magazine*, 25 April 1834, p. 160.
2. Andrew Motion, *Keats* (New York: Farrar, Straus and Giroux, 1998), p. 166.

it was Keats's biographer Richard Monckton Milnes who suggested that Tennyson should emulate Keats in his choice of home, and on a visit to the island Tennyson learned of the availability of Farringford, a large house near Freshwater. On viewing the property, Tennyson found it 'looking rather wretched with wet leaves trampled into the downs', but something in the building and the surroundings filled the poet with a sense of home. The urgency he felt was enough to bring the ever fragile, pregnant Emily over to the island by rowing boat, having missed the steamer from Lyndhurst. As always in one accord, Emily agreed with her husband. Standing at the drawing-room window she thought, 'I must have that view.'[3]

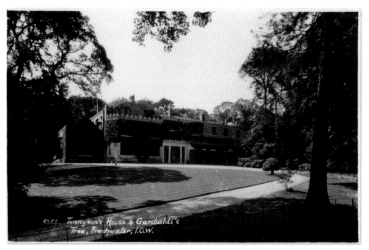

Farringford

In the autumnal mist of November 1853 the Tennysons and their one-year-old son Hallam moved to Farringford, taking their servants with them. For some of the staff it was not a happy move: 'two of the servants on seeing [Farringford] burst into tears saying

3. Thwaite, *Emily Tennyson*, p. 264.

they could never live in such a lonely place';[4] however for the Tennysons that was exactly the point.

Getting to Farringford was a challenging journey in 1859. Julia would have had to travel by train to Brockenhurst in the New Forest, then take a coach or some other conveyance through to Lymington on the coast, then a ferry to Yarmouth on the westerly edge of the island. From Yarmouth a coach and horses took you to Farringford on the edge of the village of Freshwater, by the bay. Charles Cameron had visited before and thoroughly approved of the health-giving climate and beautiful views. Queen Victoria's island residence, Osborne House, had been completed in 1851, but the Isle of Wight had remained a quiet, secluded corner of England. Possibly it was the absence of her husband, and the comforting presence of her most beloved friends, but in the seclusion of the island Julia immediately decided to let the house in Putney and split her time between Farringford and Juley's home in London. The news returning from Ceylon via the precious letters home was not good, as Charles's health, instead of recovering in his beloved Ceylon, was failing fast. Julia in desperation wrote an impassioned letter to her husband in 1860: 'Life is not so very full of years to any of us – and long absences dwindle away what is already in the course of nature dwindled to a short span – So come home.'[5]

Cameron's health was practically destroyed by the trip, and on his return to England he needed many months of nursing, increasingly in Freshwater. In the autumn of 1860 Julia purchased two adjoining houses a short walk away from Farringford and the cliffs of Freshwater Bay. They were acquired from Jacob Long, a local sailor and lodging house keeper in the village.

The two houses were linked by a central tower but kept separate until 1871, with the Cameron family living closer to the road in

4. John Batchelor, *Tennyson: To Strive, To Seek, To Find* (New York/London: Random House, 2012), p. 205.
5. Quoted in Olsen, *From Life*, p. 112.

Uncle Charles & Aunt Julia's house at Fresh Water Bay Isle of Wight.

Dimbola Lodge *c.* 1871, unknown photographer

the right-hand building, Dimbola Lodge, named for the valley of one of the Cameron's coffee plantations, and guests in the left-hand house, Sunnyside.[6] Charles gave the move his entire blessing in the form of a poem:

> The English Channel famed in war,
> The Solent sea, the winding Yar,
> Have cut an islet, yet not quite
> An islet from the Isle of Wight,
> For 'twixt the Channel famed in war
> And silent sources of the Yar,
> Dry land the twentieth of a mile

6. Advertisement in the *Standard* when the Camerons were selling the property, 15 July 1878.

Unites it to the parent isle.
There dwell I, fronting Afton Down,
With little Yarmouth for my nearest town,
The little Yarmouth where the Yar
Though hindered by its gathering bar
After four miles of winding reach
At length divides the yellow beach,
And meets in Solent brine the rills
That southward flow from Hampshire's hills.
There dwell I nowise unreproved,
By those who loving and beloved,
Think that to them I ought to give
The remnant that I have yet to live.
Nor can they cease to wonder why
I let the gusty Solent lie
'Twixt me and them, 'Twixt me and all
That men 'the World and Life' do call.
No idle motive hath my will inclined,
But such as well might sway an earnest mind,
Such as to all may gladly be confessed
To dwell united by the chosen nest,
And hear the Nightingale that sings unseen
In the dark ilex, on the flowr'y green
That carpets Farringford's muse-haunted scene.[7]

A short distance from Freshwater Bay and its wealthy, recent inhabitants, the houses in Pound Green were filled with the people who led far more modest lives than their new cosmopolitan neighbours. Farm labourers made up the majority of the entries in the 1851 census, but there was also a postman, a baker, and John Hillier, the village shoemaker. His wife Martha and he had married later in life than their peers: he was already in his thirties,

7. Quoted in Weld, *Glimpses of Tennyson*, pp. 71–72.

Charles Hay Cameron Esq. in his garden at Freshwater (1865–67) Julia Margaret Cameron

Martha twenty-nine. By 1851 their small house was filled with five children: William, born around seven months after John and Martha's wedding, in 1839, Walter, born in 1842, Sophia in 1845, followed in 1847 by Mary Ann (sometimes spelled 'Maryann') – who would be Mary Hillier, central to our story as Julia's servant and model – and lastly George, who was only ten months old at the time of the 1851 census. In a decade the farm labourers were replaced by bricklayers, gardeners and dairymen, possibly reflecting the changing nature of the village after the arrival of the Poet Laureate and his friends, as much as changing agricultural practice.

A decade later, the Hilliers' eldest daughter Sophia had found employment as kitchen maid to the Tennysons at Farringford, and Walter worked as a groom in the stables for a while. That same year, Mary Ann was sent on an errand to Dimbola Lodge. For the chaotic Cameron household the chance to acquire another parlour maid was too good, especially one related to a maid in the Tennyson household. As compared to London, the chances of finding good servants in the village were not especially favourable. The acquisition, training and retention of good servants was paramount in the running of an orderly and appropriate Victorian lady's household. Publications aimed at mistresses of houses both large and more modest gave pages to building the confidence of the lady of the house so that she would be able to manage. It was not said within the pages, but many a new mistress of a household was not much older than her staff, and on occasion not far removed in social position. That is not to say that those same publications did not criticise the English way of doing things. Louisa Rochfort, a Pre-Raphaelite model[8] and former actress at the St James's Theatre, credited with launching the career of no less a personality than Sir Henry Irving, wrote in her *St James's Cookery Book* that 'In a French family two servants are considered quite an establishment. People in the same condition of life in England would keep four if not five.

8. Also known as Ruth Herbert.

Unfortunately, nearly every English person has a house larger than his means warrant. This is a source of great extravagance – a sure way of getting into debt.'[9] However, despite the extravagance, great management makes a good company, presumably both domestically as well as theatrically, as Rochfort concludes:

> In the management of a house there are dozens of details and hints that cannot be imparted by written or oral instruction; you must learn them for yourself, and once learned they are never forgotten. Your fate is in your own hands; you are mistress of yourself though your servants leave. Have faith in your abilities, you will be a better mistress of a house from your mental training, from your education, and from your books. Brains tell everywhere, to say nothing of intelligent observation, just judgement, a faithful memory, and orderly habits; these are the great essentials for her who would, with ease and pleasure, direct a household in such a manner that not only her husband and her children, but even her servants, shall, when she dies, rise up and call her blessed.[10]

Guests to Dimbola Lodge would not have found an orderly household. When all the housemaids were involved in the process of photography, nothing else mattered to the mistress of the house. Guests got used to answering the door, including the artist Marie Spartali, who was engaged in posing for Julia during her stays at the Spartali family vineyards on the island. When there was a ring at the door, 'Miss Spartali in all the finery of "Hypatia" in whose guise she was posing, went to answer the summons. "Oh!" gasped

9. Louisa Rochfort, *St James's Cookery Book* (Brighton: Robinson Printing Co., 1903), p. 2.
10. ibid., p. 4. By coincidence the final line is the basis of the Bible quote used on Mary Hillier's gravestone.

the visitor, "are you the beautiful parlour-maid?"'[11] Through Julia's photographs, Mary (as she had become) Hillier, 'the beautiful parlour-maid', became as great a draw as the woman who had created and curated her image.

Anne Thackeray, William Makepeace's daughter, was a guest at Dimbola Lodge, and despite her love for her hostess she had to admit that the dinners were 'shockingly bad'.[12] Given the reports of them, they would be unfamiliar to those who had not had the benefit of a colonial upbringing. One description included 'gravy soup and curry' (mulligatawny soup and meat), not only as a restorative to Charles Cameron but served to guests, unused to the spices of the East. However, the chance to admire the beautiful face of Mary Hillier in a print, pressed eagerly upon her guests by Julia, then meet that paragon in the flesh, and in such a lowly station, proved irresistible to most guests and coloured their reminiscences many decades later. One writer remembered: 'there were maid-servants transformed into Madonnas, who cooked in the kitchen and waited upon the guests in the dining-room.'[13] There must have been a frisson at the simultaneous elevation and reinforcement of station between the guests and Mary, sometimes holding the Christ Child, sometimes a dish of curry.

The households at Farringford and Dimbola Lodge remained close enough that when Sophia Hillier was absent from work for two months Emily Tennyson turned to her neighbour for the use of Mary. In her household records for 23 May 1863 Emily Tennyson recorded a sum of 8 shillings paid to Mary Hillier 'in Sophia's absence',[14] followed by another payment of 2 shillings and 4 pence on 13 June. If life at Dimbola Lodge was quite relaxed and bohemian, Farringford was another country. At the heart of

11. Hill, *Julia Margaret Cameron*, p. 117.

12. Quoted in Henrietta Garnett, *Anny* (London: Pimlico, 2006), p. 55.

13. Taylor, *Guests and Memories*, p. 214.

14. Unpublished Tennyson record, in the Tennyson Research Library, Lincoln.

both homes was the creation of art; however the atmospheres were polar opposites. Emily Tennyson produced a 'General Order for Domestic Staff', a handwritten bible of commands for the ease and gentility of the Tennyson household. It covered the order in which the rooms should be cleaned, and also the conduct and appearance of the staff in exacting detail. There would be no chatter, and a reverent hush would be the order of every day. This was probably intended to aid the poetic work of Tennyson, but it also aided the rest of Emily. In addition all servants would have a high standard of personal hygiene and hair would be brushed and neat. To modern eyes it might seem patronising, but homecare manuals such as those by Mrs Beeton and Louisa Rochfort's instructed you to tell your servants exactly what was expected of them to save confusion.

If the instruction and training of Mary Hillier seemed straightforward, Julia's intention to train twelve-year-old Mary Ryan as a maid was not. Her plan was sometimes derailed by treating her as one of her own children and allowing her to take lessons alongside her youngest sons in the hands of a Russian governess named Theda Besbold.[15] When Henry Taylor arrived for a visit in 1861 he was rather puzzled to find a very pretty girl of thirteen sitting beside the Cameron boys, being taught and enjoying her reading. On learning her identity, Taylor did not hold back his misgivings to his hostess: 'What will become of her? If she is to be a good servant, I am afraid there is no such thing as a good servant who is fond of reading. If she is to be a governess, will she be any happier than governesses who have not been beggars?'[16] Taylor could not get a reasonable answer. Telling the story to Lady Mary Labouchere, he did concede that Julia had 'more of hope than of reason' in her, but had such strength of character and humanity that nothing she began would be beyond her control, and her little beggar maid would not prove an exception.

15. The surname is uncertain, as the census return is smudged.
16. Taylor, *Autobiography*, p. 186.

The household that Julia established at Dimbola Lodge was an eclectic mix, reflective of her travels. It consisted of a Northumbrian cook, Jane Lisle; a loyal lady's maid, Ellen Ottignon, who had joined the household in London; and William Hemmings, a fourteen-year-old page from Rockhampton, son of the improbably named Theophilus Hemmings, a labourer living in Putney. The local girl Louisa Young had joined the staff as parlour maid when the family arrived on the island, but her tenure was brief. She left to care for her father in 1863 on the death of her mother and was replaced by another Freshwater girl (and a third Mary), Mary Kellaway. The household was run as well as could be expected.

The weeks Mary Hillier spent as maid to the Tennysons were eventful, not least because of the arrival in Freshwater of the Swedish photographer Oscar Rejlander. Rejlander had landed in Hull in the summer of 1839. He was a young bookkeeper, but that profession did not interest him long: by the 1841 census he was lodging in Lincoln and working as an artist. In 1848 his painting *Oh Yes! Oh Yes! Oh Yes!* was exhibited at the Royal Academy, but again Rejlander had not quite found his calling. In a trip to the 1851 Great Exhibition he saw Daguerreotype images for the first time. While not seeing the artistic potential of the new medium immediately, Rejlander apparently started a brisk trade in studies for artists who may have included Edward Burne-Jones.[17] Painters turned to photography as a way of capturing a model in a pose which otherwise might be a lengthy, uncomfortable and costly palaver. Draped figures such as Rejlander's *Flora contemplating Vanity* (1860) and nudes taken from Rejlander's ambitious production *Two Ways of Life* (1857) must have been much in demand.

Rejlander may have first met Julia Margaret Cameron at Little Holland House: Julia's passion for the new art form involved her

17. Quoted in Edgar Yoxall Jones, *Father of Art Photography: O. G. Rejlander, 1813–1875* (Newton Abbot: David and Charles/Greenwich, Conn.: New York Graphic Society, 1973), p. 97.

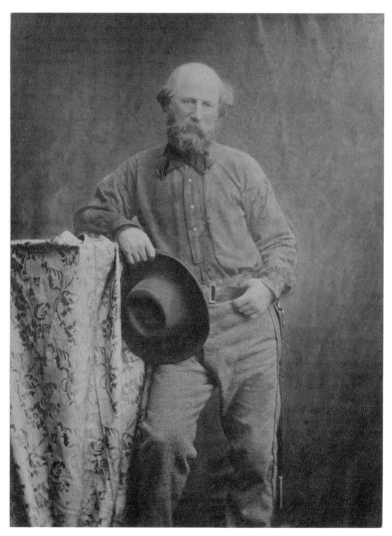

Self Portrait as Giuseppe Garibaldi (*c.* 1864) Oscar Rejlander

Study from Two Ways of Life (1857) Oscar Rejlander

assisting other photographers, including her brother-in-law Lord
Somers. Watts may have brought Rejlander into the circle with
requests for photographic studies. Once admitted to the circle,
Rejlander used the young Julia Jackson, daughter of Julia's sister
Mia, as a model repeatedly in the 1860s. In Helmut Gernsheim's
biography of Julia there is further evidence of the relationship
between the two photographers, in an incident that occurred later
in their relationship, after Julia had taken up the costly business
of taking and developing her own photographs. Ever aware of the
Cameron family's precarious finances, Julia read an article about
how silver could be recovered from waste photographic solutions.
Gathering a dozen pots filled with her old chemicals, Julia took
a hansom cab to Rejlander's lodgings, demanding to be shown
how to manage it. Gernsheim asserts that at this point they were

Flora Contemplating Vanity (1860) Oscar Rejlander

'complete strangers', and that Julia had taken it upon herself to find him out to demand the secret: that is a mistake, as we know that Rejlander and Julia were acquainted before she owned her first camera and so would not have had chemicals to hand. Rejlander knew how to extract the silver, but had to tell her that the amount she could recover would not even have paid for her cab fare. Either way, Oscar Rejlander arrived in Freshwater in May 1863 – ostensibly to take a small series of portraits of the Tennysons, but also to take a collection of images entitled 'Idylls of the Village'.

It seems odd that Julia's future favoured model Mary Hillier does not appear in these images alongside Marys Ryan and Kellaway, but at the time she was engaged at the Tennyson home. The two remaining Marys can be seen drawing water from the well in the garden at Dimbola Lodge. Behind them is a large glasshouse that would find other uses within a year. Two images feature the arrival of the postman, with further members of the household crowding around their mistress as she received letters. The importance in this otherwise rather mundane scene is in the knowledge that for all of her life letters brought news of Julia's friends and family: what the postman brought was the only way to hear from her loved ones, scattered across the Empire or at sea.

Julia's son Henry Herschel Hay Cameron, in an article in *Sun Artists*, published in 1891, claimed that his mother had paid Rejlander to photograph Tennyson so she could assist and learn from the sittings. It is possible that both Julia and Mary Hillier aided Rejlander at Farringford with the sequence of images of the Tennyson family walking in the grounds of their house. Considering the Tennyson family's stricter attitude to servants, Mary Hillier was unlikely to be modelling for any photographs; besides, the focus for the images at Farringford were the Laureate and his family. Some images show the family bathed in sunlight with the house behind them, while others show the figures dappled with shade

Portrait of a Young Hallam Tennyson
(1863–64) Oscar Rejlander

among trees. A likely explanation is that Rejlander moved the Tennysons and turned his camera rather than spending the day trailing the grounds of Farringford with his equipment. Remaining close to the house would have been desirable in the production of wet plate photographs, when time is essential. Rejlander's photographs are more akin to informal family images than any photographs of the Poet Laureate and his family taken previously, and the involvement of Julia may explain the family's patience with the whole process and the results. Anne Thackeray – later Anne Ritchie – wrote: 'There is a photograph I have always liked, in which it seems to me the history of this home is written, as such histories should be written, in sunlight, in the flashing of a beam, in an instant, and forever.'[18]

18. Anne Thackeray Ritchie, *Records of Tennyson, Browning, Ruskin* (New York: Harper, 1892), p. 40.

A Christmas Carol

JULIA HAD TO WAIT UNTIL CHRISTMAS 1863, when she was forty-eight, to own her own camera. Before that, when bored she was capable of the highest levels of interference and involvement in the lives of those she loved, and so her daughter, occupied with a husband and children of her own, thought it best to present her mother with an occupation. Julia received a wooden box camera from Juley and Charles Norman, with the words 'It may amuse you, Mother, to try to photograph during your solitude at Freshwater.'[1] Julia swiftly acquired the chemicals to sensitise and develop her plates, with the coal house changed into a darkroom. The glazed chicken house in the garden was liberated, the hens freed 'and I hope and believe not eaten'[2] by foxes, and with her endless gusto Julia set about creating her very own photographs. 'All thro' the severe month of January I felt my way literally in the dark thro' endless failures', Julia recounted in a letter to Herschel[3] but she was not quite the ingénue in photography that she implied. She was also not alone: Mary assisted her, as did the maid Ellen Ottingnon and local girl Kate Shepherd. However with Ellen senior in the household staff and Kate not living at Dimbola Lodge, most of the work fell to Mary.

1. Cameron, Woolf and Fry, *Julia Margaret Cameron*, p. 48.
2. ibid., p. 49.
3. Quoted in Ford, *Julia Margaret Cameron*, p. 35.

The process Julia chose was wet collodion,[4] invented in 1851 by Frederick Scott Archer, a sculptor, who had spent several years experimenting in coating glass panes with a tough clear film that could be sensitised with silver nitrate. The chemicals gave Julia's friends concerns. Herschel wrote warnings to take care: 'your free use of the dreadful poison the Cyanide of Potassium – letting it run over your hands so profusely. – Pray! Pray! Be more cautious', and enclosed a recipe for cleaning silver salts off her hands.[5] In one worrying incident, a cut on her finger was bathed in the poisons and Julia had to be marched about the room in an attempt to keep her conscious. Another result of using the silver salts in her processing was the staining of her hands and anything with which they came into contact, as she complained to Herschel in 1864:

> It is such a deadly poison – need I be so very afraid of the Cyanide in case of a scratch on my hand? – And when my hands are as black as an Ethiopian Queen's, can I find no other means of recovering and restoring them but this dangerous Cyanide of Potassium? Are any of the Chemicals prejudicial to health if inhaled too much?[6]

In the photographs none of the maids has staining on her hands. Mary Hillier often appears with her hands clasping a child or held together in prayer. Julia's efforts to leave Mary unblemished by the process is in keeping with her need for her to play a role in the photographs other than just being an assistant.

The coal house, separate from the house, did not have any running water, so buckets of water had to be fetched for each negative – up to nine buckets – testing the fortitude of both mistress and maid, as the water was drawn from the freezing well

4. Gun cotton dissolved in ether and alcohol.
5. Unpublished letter, 1867 quoted in Ford, *Julia Margaret Cameron*, p. 39.
6. Unpublished letter, 20 March 1864, ibid.

in January. The significance of Rejlander's photograph, *At the Well,* may have been that the maids had fetched him water for his glass plates, but in the depths of winter it is doubtful that their faces would have been so cheerful. Julia's hands became chapped with the cold and stained with the chemicals, which splashed the linens in the house. In the summer, people passing the idyllic lane outside Dimbola Lodge found the scent of chemicals mingling not entirely pleasantly with the fragrance of the honeysuckle and roses in the garden.[7] Hours must have been spent in semi-darkness, mistress and maid, in summer and winter, the acrid smell of the chemicals all pervasive as they struggled to conjure images on panes of glass. Even if Mary remained unstained by the collodion, the smell must have clung to her clothes and hair at all times.[8]

On 29 January 1864 Julia developed what she regarded as her first triumph, a photograph of seven-year-old Annie Philpot, daughter of the vicar and poet William Benjamin Philpot, who was on holiday on the Isle of Wight. Before this Julia had unsuccessfully attempted multiple images of a local farmer, and had paid for his trouble, but the glass plates had been damaged in her haste and excitement. Now Annie had been entreated to sit for Julia with her cousin Margaret Louisa (Daisy) Bradley, but the combination of the little girls together was not successful. The images required the sitters to be absolutely motionless over several minutes: 'I was half-way thro' a beautiful picture when a sputter of laughter from one of the Children lost me that picture.'[9] Annie was

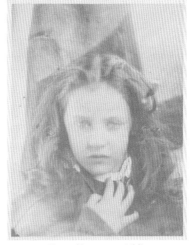

Daisy (January 1864)
Julia Margaret Cameron

7. Hill, *Julia Margaret Cameron*, p. 106.
8. Troubridge, *Memories and Reflections*, p. 34.
9. Cameron, Woolf and Fry, *Julia Margaret Cameron*, p. 49.

taken aside and told of the waste of poor Mrs Cameron's chemicals and strength if she fidgeted, and the child was induced to sit once more, on her own. On the card that accompanied the photograph Julia recorded that Annie had sat for the photograph at 1pm and the print was finished at 8pm – seven hours' work to produce one successful image. In the letter to Annie's father Julia claimed that Annie's 'docility and sweetness' had greatly contributed to the success of the photograph.

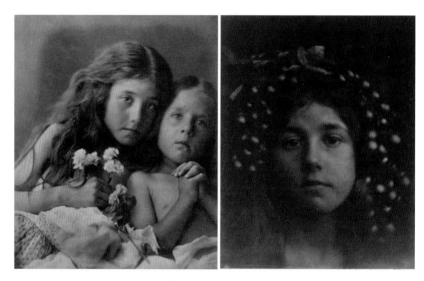

LEFT: *The Red and White Roses* (Kate and Elizabeth Keown)
(August 4 1865) Julia Margaret Cameron
RIGHT: *Circe* (Kate Keown) (1865) Julia Margaret Cameron

Julia's first steps in image making now seem tentative; a flurry of children suddenly appear clutching each other with round cheeks. Kate and Elizabeth Keown, daughters of a local soldier, pose naturally in each other's arms. Juley's family is celebrated with images of daughter Charlotte together with Juley and Charles Norman in affectionate scenes. The cherubic local boy, Freddy Gould, is captured as a foil for Kate Keown, the Paul to her Virginia, and Hallam and

OPPOSITE: *Annie* (January 1864) Julia Margaret Cameron

Annie

My very first success in Photography
January 1864

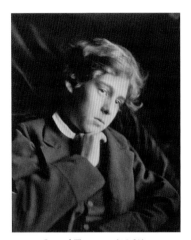

Lionel Tennyson (1869)
Julia Margaret Cameron

Lionel Tennyson make their first appearance in Julia's art in blurry, fragile images of their young faces. However it was only a matter of time before her lens turned to another subject that would come to define a dimension of her art for the length of her career.

In his autobiography, *Notes from the Life of an Ordinary Mortal*, Adolphus Liddell, society figure and lawyer, recalled his memories of Julia, which lead with her ruling passion: 'She had an intense devotion for great men in general, and Henry Taylor in particular. From what I can remember her devotion must have had its drawbacks, as she not only laid on the butter very thick, but took almost entire possession of her idol.'[10] Previously her possession could only be expressed in momentary actions bestowed upon the recipient, happy or otherwise, but now, armed with a camera, that possession could be total and permanent. The objects of her devotion need not be present for her to possess them, for she would have them collected and mounted in a frame. When Virginia Woolf came to publish a book of her great aunt's photographs in the 1920s it was entitled *Victorian Photographs of Famous Men and Fair Women*. This was possibly an acknowledgment that Julia's photographs tended to celebrate men for their fame and women for their beauty, but that was a reflection of how society worked at the time. One of Julia's earliest male 'victims' in the real world, Pre-Raphaelite painter William Holman Hunt, remarked that 'she was perhaps the most perseveringly demonstrative [of the Pattle sisters] in the disposition to cultivate the society of men of letters and art'.[11] Now, through

10. Liddell, *Notes from the Life of an Ordinary Mortal*, p. 5.
11. William Holman Hunt, *Pre-Raphaelitism and the Pre-Raphaelite Brotherhood* (London: Macmillan, 1905), II, p. 123.

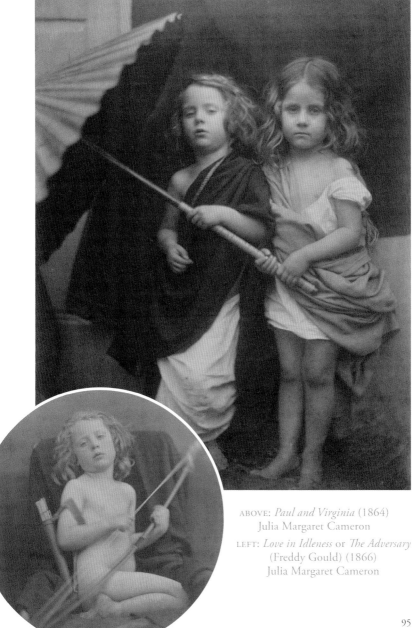

ABOVE: *Paul and Virginia* (1864)
Julia Margaret Cameron

LEFT: *Love in Idleness* or *The Adversary*
(Freddy Gould) (1866)
Julia Margaret Cameron

Henry Taylor (10 October 1867) Julia Margaret Cameron

the wonder of a modern art, her love could be expressed in ways other than *decalcomanie* and presents, by capturing her subject as an immortal, a marker of greatness.

Unsurprisingly, the lens turned swiftly to Henry Taylor. Julia recorded in *Annals of My Glass House* that:

> Our chief friend, Sir Henry Taylor, lent himself greatly to my early efforts. Regardless of the possible dread that sitting to my fancy might be making a fool of himself, he, with greatness which belongs to unselfish affection, consented to be in turn Friar Laurence with Juliet, Prospero with Miranda, Ahasuerus with Queen Esther, to hold my poker as his sceptre, and do whatever I desired of him.[12]

The results were a series of images of the handsome old man, his white beard sparkling in contrast to the dark drapery, his head often topped with a tinselled crown. Despite being one of the foremost poets of the age and a distinguished gentleman, he was not above being posed with the maids, appearing with Mary Hillier in *Bathsheba brought to King David* (1865–66) and two separate versions of *Friar Lawrence and Juliet* (both 1865). His patience, good humour, and most importantly his stillness helped Julia to achieve some of her more satisfactory group images, but it is in her portraits of him that her talent was revealed. Taylor sent one of the images to a friend, who replied with thanks 'for the beautiful likeness of yourself … I do not think you look like a Christ-like Jove but, much better – yourself. I often stop my visitors on the stairs to notice your portrait, the best I think, of those which our friend, Mrs Cameron, took with such infinite pain and labour.'[13] Despite Julia's constant praise of his beauty in her photographs, Taylor took it in good humour, referring to the images of his

12. Cameron, Woolf and Fry, *Julia Margaret Cameron*, pp. 55–56.
13. Taylor, *Guests and Memories*, p. 311.

LEFT AND RIGHT: *Henry Taylor* (1864) Julia Margaret Cameron

beard as 'The Flower of Love Lies Blanching'.[14] No one on viewing
Taylor's magnificent beard can be in any doubt of its attraction for
the photographer, and Taylor himself wryly explained its existence
in his autobiography:

> There is a feature of my life, conspicuous in these
> photographs, which dates from this period, and the
> importance of which far be it from me to underrate. This
> is my beard. In 1859 my hand was so liable to be shaken
> by asthmatic spasms that the razor was not safe in it,
> and was laid by… You inquire of the colour… white,
> white as Apalachia's snows! What *can* be the reason? The
> cruelties of women, I think.[15]

On seeing his rival poet's face beatified by Julia, Tennyson grumpily
commented that Henry Taylor had a smile like a fish. To this Julia

14. Hill, *Julia Margaret Cameron*, p. 115.
15. Taylor, *Autobiography*, pp. 197–98.

replied, 'Only when the Spirit of the Lord moved on the face of the waters, Alfred.'[16] The celebrated portraits of Tennyson followed as often as Julia could persuade him, as related by the poet's niece Agnes Weld:

> [Julia's] complete freedom from affectation was a great refreshment to Tennyson, and even made him bear patiently the many scoldings she gave him for refusing to waste (as he considered) the precious hours of lovely summer mornings in sitting to her for his photographs. Unfortunately for my uncle she had discovered what an immense source of pleasure to her friends her photographs of him were.[17]

Her photograph of him known informally as 'The Dirty Monk' was Tennyson's favourite of all his portraits, save one by the commercial photographer John Jabez Edwin Mayall, known for his photographs of the Royal Family. To Julia this was like comparing the heroic, iconic busts of Pre-Raphaelite sculptor Thomas Woolner to a wax head from Madame Tussaud.[18] The 'Dirty Monk' was the picture that Julia used as a frontispiece to her 1874 and 1875 volumes of photographs illustrating the poet's *Idylls of the King*. Her photographs of him were so well known and widely distributed that Tennyson complained of hotels and restaurants that 'They charge me double! and I can't be anonymous (turning to Mrs Cameron) by reason of your confounded photographs.'[19]

Despite Julia's worship of Taylor and Tennyson, arguably her favourite male model was Charles Cameron. After a dinner party one evening, from which Cameron had been absent, Julia took

16. *Mrs Cameron's Photographs from the Life*, p. 29.
17. Weld, *Glimpses of Tennyson*, pp. 65–66.
18. Lukitsh, *Julia Margaret Cameron*, pl. 13.
19. Radford, *William Allingham: A Diary* , p. 185.

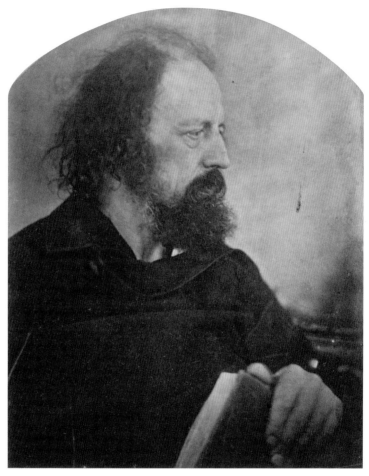

Alfred Lord Tennyson, also known as *The Dirty Monk* (1865)
Julia Margaret Cameron

the guests up to where he was sleeping, entreating them to 'behold the most beautiful old man on earth'. When her guests, puzzled, enquired who he was, she stated proudly that it was her husband.[20]

20. Melville, *Julia Margaret Cameron*, p. 53.

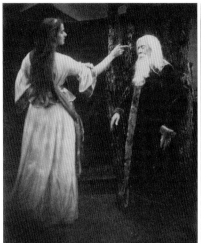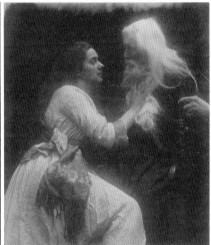

LEFT AND RIGHT: *Vivien and Merlin* (1874) Julia Margaret Cameron

Cameron posed with maids and visitors, including the Liddell sisters, Alice (of *Alice in Wonderland*), Lorina and Edith, who were staying in the nearby Whitecliff House in Freshwater. In *King Lear allotting his Kingdom to his Three Daughters* (1872) the dark-cloaked, seventy-seven-year-old Cameron is surrounded by the beautiful young women – Alice to his right, Lorina and Edith cropped over his left shoulder. However, unlike the ever patient Taylor, Cameron's sense of mischief often derailed his wife's attempts to capture the desired image. An amateur female photographer writing in 1886 recalled the trouble experienced while posing with Cameron for *Vivien and Merlin* (1874). In the final successful images, with a different model, Julia posed the sorceress with her fingers entwined in Cameron's silvery beard. (Other exceptions to her normally chaste representations are images of Mary Ryan and Henry Cotton as *Romeo and Juliet*, and May Prinsep and Andrew Hitchens as *Gareth and Lynette*. In those cases the couples were engaged, and the images of the lovers were done in celebration of this.) The writer of the article

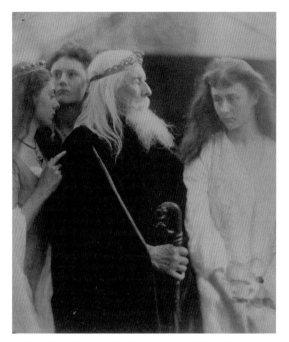

King Lear allotting his Kingdom to his Three Daughters
(1872) Julia Margaret Cameron

was uncomfortable playing the temptress Vivien, which may partly account for the failure of her set of images, because she 'did not seem to be a very nice character to assume', but the real blow was when she found out who her Merlin was to be: 'Mr Cameron, with his silvery hair and long white beard, being an admirable representation of the patriarch, there could not be a shadow of a doubt; but would he laugh?'[21] The answer was vociferously, until there were at least fifty Merlins to be seen on the finished plate: 'With an "Oh, Charles, Charles," half good natured and half reproachful, Mrs Cameron gave Merlin up, at least for that day.'[22]

21. *Photographic News*, 1 January 1886, p. 3.
22. ibid. Julia finally had success with Agnes Mangles in the role in 1874.

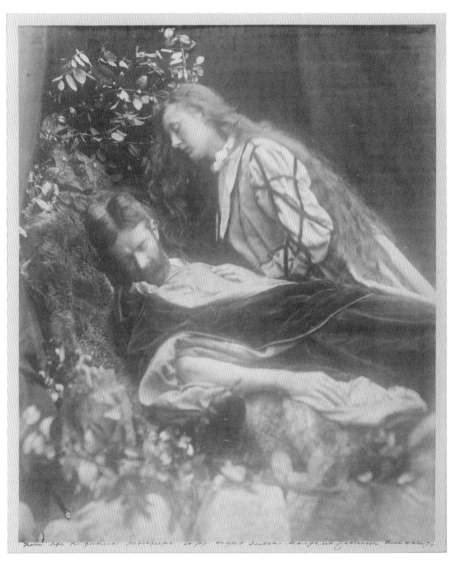

Gareth and Lynette (1874) Julia Margaret Cameron

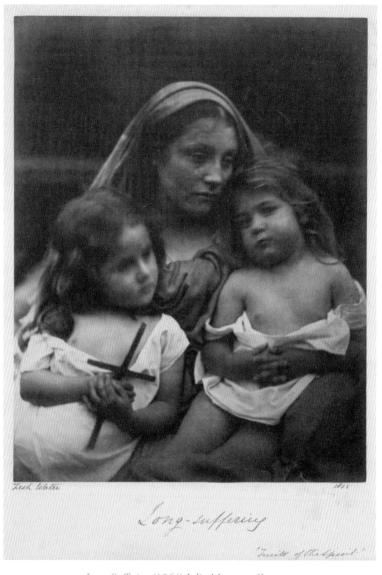

Long-Suffering (1864) Julia Margaret Cameron

Hosanna

TURNING FROM THE IMAGES of the children and her heroes, Julia found the perfect role for Mary Hillier in December 1864: that of the Madonna. Beginning on 12 December and extending through the new year, Mary posed as the Madonna with the young Keown sisters. Julia captured a range of Christian virtues with Mary as the key, including *Love* (1864), *Joy* (1864), *Long-Suffering* (1864), *Goodness* (1864) and *Peace* (1865). Recurrently, Mary appears heavily draped in fabric including a halo-cowl around her hair in contrast to the bare skin of the girls, sometimes wearing the briefest of garments as they hold on to her. In *Repose* (1864) Freddy Gould is swathed in the endless swirl of Mary's gown, essentially 'tucking him up' comfortably against her, probably in an inducement to keep still. Each virtue that Mary portrays seems to blend into the next with very little difference between *Meekness* (1864) and *Faith* (1864). In November Mary had appeared as the Virgin Mary in the expressively titled *La Madonna Addolorata (Patient in Tribulation)* (1864) and *La Madonna della Ricordanza (Kept in the Heart)* (1864). The season of beatitudes continues in March 1865 with Mary cradling Freddy Gould once more as *La Madonna Aspettante (Yet a Little While)* (1865) – possibly the instruction given to the child as he grimly reclined on the maid's lap.

Julia wrote of her friends 'the men great through genius, the women through love – that which women are born for',[1] and

1. Taylor, *Guests and Memories*, p. 228.

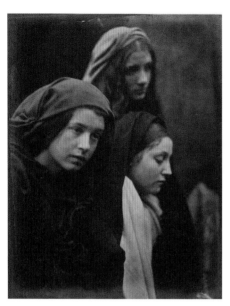

The Three Marys (1864)
Julia Margaret Cameron

through her images of Mary as the Madonna Julia creates the pinnacle of that maxim. Mary represents love, maternal love, which Julia prized above all other forms of devotion. She is the ideal, bestowing kisses, cradling, watching over the child as it sleeps. Often pictured looking to the side to show off her beautifully shaped profile, Mary is watchful and patient, but elevated by the very act of being the blessed Virgin. There are a few images of Mary as a working-class girl – one as a flower seller, another as the wife of a fisherman – but the majority show Mary as the Madonna, the epitome of a working girl made holy, just as Julia raises Mary up to be a work of art.

Away from her role of the Madonna, Mary found herself posed with the other maids in the house. In *The Salutation* (1864), Mary Kellaway kisses the forehead of her sister-maid and in *Yes or No?* (1865) Mary Kellaway clasps Mary Hillier's hand while considering a letter that either contains or requires an important answer. They are joined by Mary Ryan, most notably in *The Three Marys* (1864), which has both biblical and literal meanings. In these early images Mary is joined on at least three occasions by her elder sister Sophia, borrowed from Farringford and not promptly returned. They stand side by side clutching lilies in *Decidedly Pre-Raphaelite* (1864–65), as the *Daughters of Jerusalem* (1865) and directly behind the two the Keown sisters in *Sister Spirits* (1865).

The following year saw Mary pose with May Prinsep, Thoby Prinsep's niece. May was born in Calcutta in 1853, and after losing

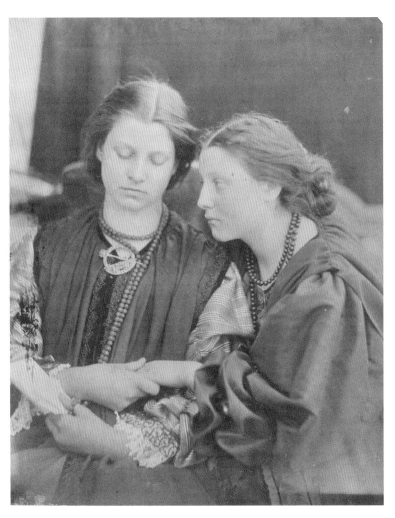

Yes or No? (1865) Julia Margaret Cameron

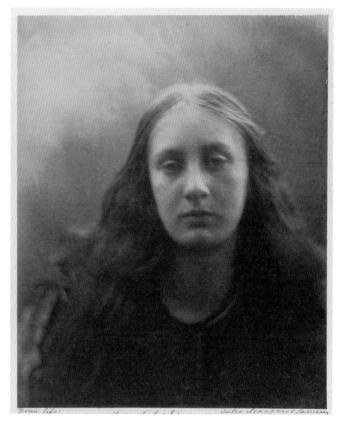

Christabel (1866) Julia Margaret Cameron,
showing May Prinsep as the subject of a poem by Coleridge

both her parents had come to live at Little Holland House with her
uncle in 1864. Young and pretty, she was immediately welcomed
into Julia's coterie of models, posing in 1866, aged only thirteen,
with Mary in *The Dialogue* (1866), an intense piece where the
two girls face each other, without exactly making eye contact, the
difference in their height suggestive of the balance of power between
them. Henry Taylor told a story to his daughter of a journey with
Julia, May Prinsep, a model, and Marys Ryan and Hillier from

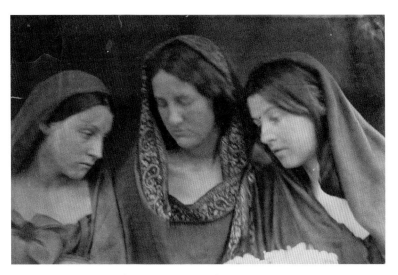

Daughters of Jerusalem (1865) Julia Margaret Cameron

Waterloo to the Isle of Wight, where it was demanded of the model that she travel second class with the maids. When this request was disobeyed, the model was 'lectured on difference of ranks and introduced to the Madonna and the Beggar-maid as models who were humble and knew their place'.[2] Despite the complication of the dynamic, Julia and Mary were able to negotiate a relationship where Mary was both the personification of biblical ideal and the girl who scrubbed the front step, with no reinforcement of her 'place' needed through photography.

Despite being a favourite model for her mistress, she was not above being a member of the chorus in large groups. In these photographs Mary is just one in a bevy of young women, as in *The Five Foolish Virgins*, approaching a smile, her face the only one in perfect focus. A decade later in *Have we not Heard the Bridegroom is so Sweet* she appears literally on the edge of the image but presenting

2. ibid., p. 216.

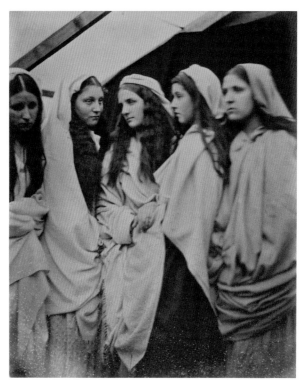

The Five Foolish Virgins (12 December, 1864) Julia Margaret Cameron

her placid countenance. In Julia's photographs for Tennyson's poem *Idylls of the King*, taken in Julia's final year in England, Mary is a handmaid to the fallen King Arthur – in real life Yarmouth labourer and part-time domestic servant William Warder. In his final journey to Avalon, depicted in *'So like a shatter'd Column lay the King'*, Mary cradles the fallen king who grasps the edge of the boat awkwardly. These images were praised by Tennyson, and Julia felt that they brought the two of them closer together: 'It is immortality for me to be bound up with you Alfred', she wrote.[3] Later critics

3. Cameron, Woolf and Fry, *Julia Margaret Cameron*, text accompanying pl. 32, p. 150.

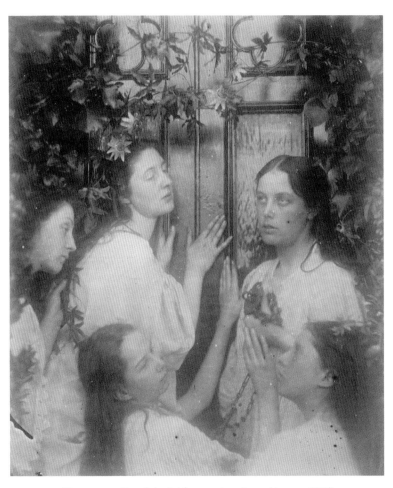

Have we not Heard the Bridegroom is so Sweet (August 1874)
Julia Margaret Cameron

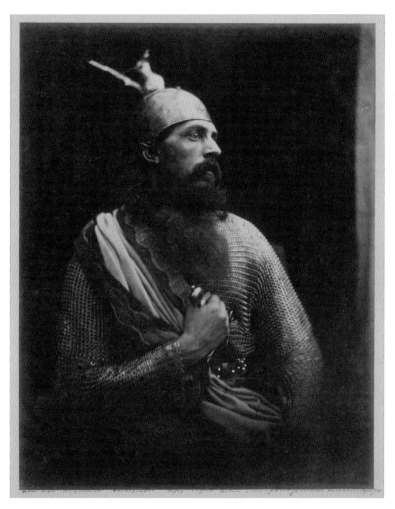

The Passing of Arthur (1874) Julia Margaret Cameron

have felt that this cycle of pictures has the 'fatal flavour of amateur dramatics',[4] but the grouping of the barely seen hooded figures in the boat lends a sinister note to the otherwise faintly humorous image of a seasick king.

Throughout the years of Freshwater photographs there are images that need no title other than simply Mary's name. Possibly intended as works with biblical or Tennysonian themes, they are known to us now simply titled 'Mary Hillier'. Within them Mary appears in her many guises, cowled in humility, crowned and regal, cast in shadow or illuminated in light. Mary is stillness in action; even when she is photographed in the act of kissing or embracing, her perfect stillness in front of the lens means that her face is quite often the only sharp point in Julia's dream-like images. This was no mean feat, as the effort to remain absolutely still for minutes at a time could be agony. One of Julia's other models described it vividly:

> A minute went over and I felt as if I must scream; another minute, and the sensation was as if my eyes were coming out of my head; a third, and the back of my neck appeared to be afflicted with palsy; a fourth and the crown which was too large, began to slip down my forehead; a fifth – but here I utterly broke down.[5]

Mary sat for hundreds of such images, and admitted later in life that she did not enjoy it, but found fulfilment in the pleasure it gave to her mistress. These torments were not to be underestimated as, in Julia's own estimation, for the *Idylls of the King* cycle she took 245 plates for only twelve finished images.[6] The only variation in Mary's placid expression is the shape of her chin, sometimes curved,

4. ibid.
5. *Photographic News,* 1 January 1886, p. 3.
6. Cecil Beaton and Gail Buckland, *The Magic Image* (London: Pavilion, 1975), p. 66.

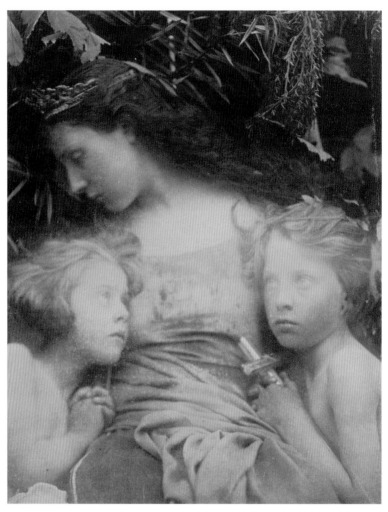

Une Sainte Famille (A Holy Family) (August 1872) Julia Margaret Cameron

sometimes lowered, sometimes a hard pucker, quietly expressing boredom, impatience, joy or excitement.

Julia was by no means alone in finding photographic inspiration in a beloved maid, but her treatment of Mary differs vastly from that of diarist, barrister and photographer Arthur Munby, and his maid Hannah Cullwick. Munby met Cullwick in 1854 and employed her not only as his maid but also as his muse, due to his fascination with working-class women. Unlike Julia's images of the Holy Mary, Munby arranged for photographs to be taken of Cullwick 'in her dirt', filthy from her domestic work, but also fetishistically filthy in roles such as a semi-naked chimneysweep (1862). For Munby it was 'the tension between the conventional feminine ideals of his day and the bodies of the strong, dirty, disfigured working class women who populated the city' that provided his inspiration.[7] Even the biblical roles he required of her were sexualised, including a bare-breasted Magdalene (1864), taken the same year as Julia was elevating Mary to the role of heavenly mother. A similar tension can be found in two images of the same girl – Alice Liddell taken by Julia and by her photographic rival Charles Lutwidge Dodgson, better known as Lewis Carroll. When Carroll photographed his child-friend Alice he chose the role of 'beggar-child', in shredded clothes. A few years later, Julia echoed the pose in her portrait of Alice, but elevated the girl to a goddess of fruitful abundance,

Lewis Carroll (1863) Oscar Rejlander

7. Faramerz Dabhoiwala, *The Origins of Sex: A History of the First Sexual Revolution* (Oxford: Oxford University Press, 2012), p. 355.

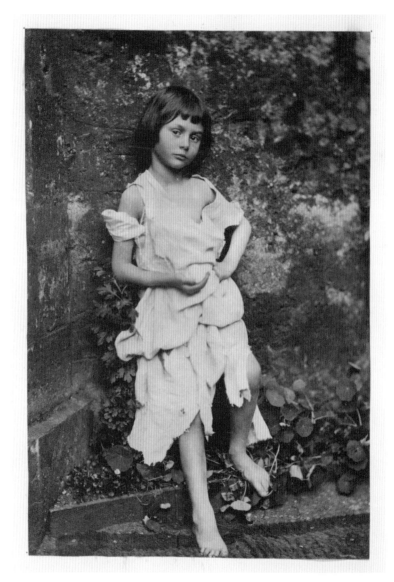

Alice Liddell as a Beggar-Child (*c*. 1858) Lewis Carroll

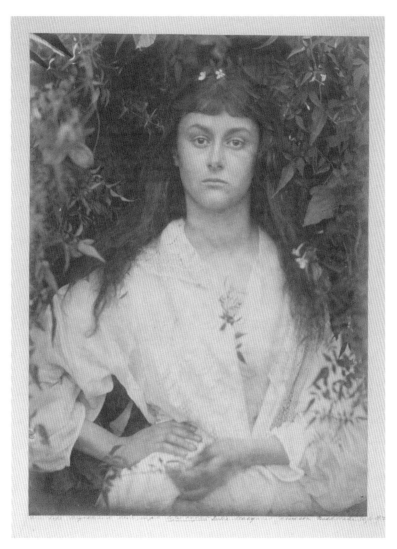

Pomona (1872) Julia Margaret Cameron

a beggar no more. Punch artist Edward Linley Sambourne also took photographs of his servants, but in more dubious circumstances. Looking upon his maids as 'amateur models' (as opposed to his use of professional models), he felt entitled to photograph them as they slept, producing images such as *Maid Sleeping in the Top Room at 18 Stafford Terrace* (1887), an image which he inscribed on the back as having been taken at six thirty in the morning. Although Julia took a similar image of Mary Ryan in *So Early in the Morning* (1864–65), the logistics of carrying the unwieldy, heavy camera, which allegedly took two men to move, into her maid's room without disturbing her, seem unlikely and the image begins to look very much constructed. Sambourne's less prettily sleeping maid has a far more realistic look about her, giving the impression of a man who took the master–servant dynamic very much for granted in every aspect of their shared lives.[8]

Due to her loyalty and presence in Julia's life from 1863 until Julia's departure from Freshwater in 1876, Mary is one of the few models, if not the only one, who appears regularly in photographs. From 1864 and the many grace-filled mothers until Julia's Tennyson illustrations and *Maud* of 1875, Mary grows from a teenager into a woman in her late twenties. Other young women, maids, relatives and momentary acquaintances, had passed through Julia's studio, but Mary remained a constant feature in front of the camera and behind it. This latter aspect of her work was described in an 1886 *Photographic News* article: the 'Lady Amateur' relates that 'Mrs Cameron, with the assistance of "Mary" – the beautiful girl who figured in so many pictures and notably in the picture called "Madonna" – bore off the gigantic dark slide with the remark that she was afraid I had moved.'[9]

The mixing of these roles was later suspected of having lasting

8. Robin Simon, ed., *Public Artist, Private Passion: The World of Edward Linley Sambourne* (London: British Art Journal, 2001), pp. 33–34.

9. *Photographic News*, 1 January 1886, p. 3.

damage for Mary, who suffered from problems with her eyes from middle age, becoming completely blind in her early sixties. While it seems clear that Mary did not handle the staining collodion, some chemicals would undoubtedly have touched her hands. Julia had a preference for freshly washed hair in her models, remarked upon by many biographers in reference to her photographs of Sir John Herschel and the 'halo about the head of her Teacher and High Priest'.[10] Mary's long tresses were regularly washed and dried by the fire in preparation for specific photographs. In later years, subsequent health issues, especially her blindness, were suspected to have resulted from this, as if the application of hands to her hair or the water over her eyes could have allowed the chemicals into her body in greater quantities or with greater ease.[11]

Just over a year after recording her first solo success with her own camera, Julia was ready to hold a solo exhibition. Having entered photographs into the Photographic Society exhibitions in London and Scotland in 1864 with some success, her energy was devoted to taking her art to an international audience. A photographic exhibition in Berlin and the International Exhibition in Dublin saw her works exposed to a wider audience, but still in the context of other people's idea of what made good photography, a notion by which she was never bound. The judges and some critics found much to comment on. The *Illustrated London News* review of the London exhibition was dismissive, grouping Julia's work with the 'novelties' and commenting that her 'out of focus' works were 'much inferior to the portraits of artists by [David Wilkie] Wynfield'.[12] However, Julia's work found an appreciative audience north of the border. The *Scotsman*'s review of the 1864 exhibition found Julia's portrait of William Holman Hunt to be 'remarkably effective' despite being disadvantageously hung, and a portrait of Watts was

10. *Mrs Cameron's Photographs from the Life*, cat. 22.
11. From conversations with Mary's decendents.
12. *Illustrated London News*, 4 June 1864.

excellent in its 'breadth of effect and artistic treatment', giving the effect of 'a replica of Rembrandt'.[13]

The reference to David Wilkie Wynfield is hardly surprising, although his work is relatively unknown today, having not experienced the renaissance in reputation that Julia has enjoyed.

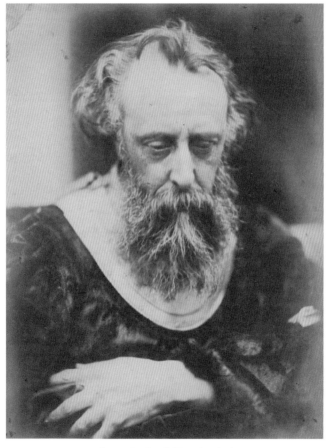

George Frederick Watts (1860s)
David Wilkie Wynfield

13. *The Scotsman*, 20 December 1864.

Wynfield existed within a group of artists known as the St John's Wood Clique, which included the painters Philip Hermogenes Calderon and George Dunlop Leslie. He, like Julia, was a child of the colonies, born in India in 1837, and many of his photographs are of people they both knew, such as the Prinsep family and Watts. Julia wrote in a letter to Sir John Herschel: 'I have had one lesson from the great Amateur photographer Mr Wynfield & I consult him in correspondence whenever I am in difficulty';[14] further to that, in a letter to William Michael Rossetti she wrote that to 'his beautiful Photography I owed all my attempts and indeed consequently all my success'.[15] One aspect of Julia's work that is shared by Wynfield, and possibly learnt from him, was the relaxing of focus for artistic effect: 'His method was to adjust the camera slightly out of focus, which softened and did away with the stereotyped hard look of the professional photographs of the day.'[16] By embracing avant-garde, experimental techniques in pursuit of an artistic effect Julia always risked disapproval, but her desire to sell her work necessitated public access. It is hardly surprising that Julia sought to display her works in solo exhibitions, away from such criticism and narrow-mindedness, and possibly also as a way of protecting herself and her models from unkind comments in the press.

One of the first recipients of a collection of her pictures was Anne Thackeray, who had taken to staying in Freshwater near Julia after her father's death in 1863. Anne and her sister had been present in the house during the first trials that led to the image of Annie Philpot, 'my first success'. The present of an album to Miss Thackeray, while in no way a cynical move, did get a very positive response in the *Pall Mall Gazette* for which Anne wrote. When Julia exhibited a portfolio of photographs at Colnaghi's Gallery in April 1865 the

14. Juliet Hacking, *Princes of Victorian Bohemia: Photographs by David Wilkie Wynfield* (London: National Portrait Gallery, 2000), p. 9.

15. Gernsheim, *Julia Margaret Cameron*, p. 60.

16. Ford, *Julia Margaret Cameron*, p. 36.

moving testimony on the quality and meaning of the images is likely to be Anne's. The images of Mary were singled out for praise:

> Mrs Cameron, the author of the work in question, is a photographer who has tried to photograph something more than a mere inanimate copy of this or that object before her, and yet the commonest stories and events of everyday life are the subjects of her art. 'Trust', 'Resignation', 'Meekness', 'Thy Will Be Done', are the names she has given to some of her pictures.[17]

Further to these, *The Salutation*, an image of Mary Hillier and Mary Kellaway, was likened to any number of, presumably Renaissance, pictures in the National Gallery, and *Trust* was described as a 'quiet woman with a noble head, with children clinging about her', a role that Mary was to become famous for. The reviewer relates that an unnamed 'well-known' photographer stated that Julia's was 'the real and artistic manner of working the camera' which he himself had not had the courage to pursue after attempting it and meeting with criticism similar to what Julia had faced.

Cheered by the success of her solo endeavours and armed with further images to show, and more importantly sell, to her awaiting public, Julia held her next show in rooms at the French Gallery on Pall Mall. Around 151 photographs were exhibited, and sold well, if the diary entry by artist George Price Boyce is anything to go by: 'November 21 – Mrs Cameron's Photograph Exhibition. I bought 5 (for which, being an artist, I paid half prices). A very pretty fair girl with lovely tender eyes and light brown hair in attendance.'[18]

This lovely girl is likely to have been Mary Ryan, spared from her household duties to assist in the business, along with Dimbola

17. *Pall Mall Gazette*, 10 April 1865.
18. George Price Boyce, *The Diaries of George Price Boyce*, ed. Virginia Surtees (Norwich: Real World, 1980), p. 43.

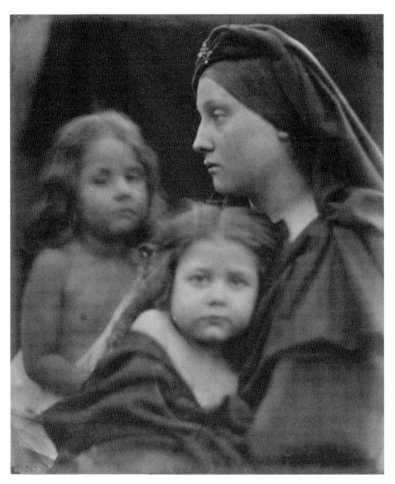

Trust (1865) Julia Margaret Cameron

Lodge's housekeeper. Among the images were two versions of *Prospero and Miranda*, featuring Mary Ryan as the kneeling girl. A young man training for the Indian Civil Service bought not only these photographs but every image that Mary Ryan appeared in, then waited patiently for the model to write out his receipt. In Helmut Gernsheim's retelling of the romance, the young lover, Henry Cotton, then appeared at the door to Dimbola Lodge and announced: 'I have come to ask for the hand of your housemaid. I saw her at your exhibition and have all the time kept the bill she wrote out for me next to my heart.'[19] Julia agreed to the match but refused him access to Mary Ryan until he had the permission of his parents, duly given. On the day of the wedding, a rather uncharitable story was that Cotton fell to his knees in front of Kate Shepherd, one of the bridesmaids, and declared that she was the woman he had fallen in love with. Julia, with great quickness of mind, despatched Miss Shepherd to Yarmouth and across the Solent, while the hapless Henry Cotton was quickly married off to Miss Ryan. This version of the story, which is untrue, says more about the mischief of the teller than about the folly and farce of the Cameron household.

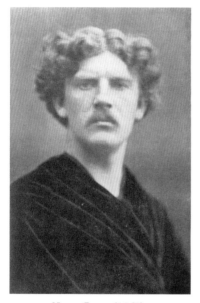

Henry Cotton (1867)
Julia Margaret Cameron

The account given by the young man, later Lord Cotton, was much happier. He had sought the friendship of Charles Cameron

19. Quoted in Gernsheim, *Julia Margaret Cameron*, p. 31.

in order to seek his advice and guidance in his career in the Indian Civil Service, and, as Cotton wrote in his autobiography *Indian and Home Memories*, it was during a visit to Little Holland House, in the romantic society of the Pattle sisters, that he saw Mary Ryan. In all likelihood, given her rather fluid position within the family, he might well have been unaware that she was a servant, but the outcome was the same:

> It was within those walls when she was staying there with Mrs Cameron, that I wooed and won the fairest of fair young girls who became my wife on the 1st August 1867, and who has since been my devoted companion and helpmate for better and for worse through many years of vicissitudes and successes, sorrows and aspirations, clouds and sunshine.[20]

Strangely, the only person who put up any sort of objection to the match was Mary Ryan's mother. There is no account of Mary's father, and it is uncertain whether he ever saw his daughter after she left Ireland as a child. In Gernsheim's account it is suggested that Mrs Ryan feared her daughter would not be happy in such an unequal match, but it is as likely that she resented her daughter's future happiness being decided by the woman who had removed her from her family. The life that Julia inadvertently shaped for Mary Ryan was a print of Julia's own – Indian Civil Service, travelling and large family. Julia presented Mary's mother with a vast Indian shawl that matched her own and sent her down the aisle on the arm of Charles Cameron. The parting comment in Gernsheim's narrative of the wedding is Mrs Ryan whispering to Cameron, while looking at her daughter marrying Cotton: 'Don't you wish it was Master Charlie?', referring to his son. Such a match seems never to have

20. Henry Cotton, *Indian and Home Memories* (London/Leipzig: T. Fisher Unwin, 1911), p. 54.

Portrait of The Hon. Frank Charteris (1867) Julia Margaret Cameron

occurred to the Camerons, who might not have been able to square the circle of Mary being on the one hand their ward, but on the other their servant and 'Irish beggar maid'.

One final bonus of the wedding, a grand affair that brought together not only the local villagers but also aristocracy and literary society, is that it provided Julia with new subjects to photograph before they escaped on the ferry back to the mainland. One victim was Adolphus Liddell, over to the Isle of Wight for the wedding, accompanied by his friend Frank Charteris, son of the Camerons' friends Lord and Lady Elcho. Liddell noted:

> I sat between the two maids, and I don't think I ever felt so shy, or had greater difficulty in making conversation. When the wedding was over Charteris and I, who were going to Cowes, had the pleasure of escorting a lovely chemist's assistant, who was bound for Portsmouth. Charteris, who had a beautiful face, did not escape the ogress of the camera, and I was myself victimised.[21]

Mary, one of the maids who sat beside Lord Elcho's son and his embarrassed companion, aided her mistress in capturing the image of these promising young men before they returned to the mainland. Frank Charteris, described by Tennyson as being 'a young paladin' or romantic knight, did indeed have a handsome face, but Julia's photograph in retrospect must have been bittersweet: it captures him shortly after he had left Balliol College, Oxford, afflicted by a persistent and mysterious illness that plagued his life for the following three years. Despite travels for a cure he returned weakened to the family home in 1870, and died examining one of his father's firearms in an accident that the press went out of their way to describe as decidedly not suicide.

21. Liddell, *Notes from the Life of an Ordinary Mortal*, p. 86.

CHAPTER NINE

Patient in Tribulation

THE SUDDEN INFLUX OF the literary and artistic crowd into
Freshwater provided benefits for the local families. The
Hampshire Advertiser printed a story at Christmas 1863 on the
beneficence of the 'wealthier classes' in Freshwater and their
bountiful gifts of beef, coal, fruit and tea.[1] In the glorious summer
of 1868 Charles Darwin, his wife Emma and their family came
to stay in Sunnyside, next to Dimbola Lodge, in order for him
to recuperate in the seclusion of Freshwater. Julia's generosity was
not unconditional, and the now iconic photographs of Darwin
were taken during his stay, together with photographs of his older
brother Erasmus and his young son, Horace. According to Darwin's
daughter, who requested that her mother, Emma, have her picture
taken, Mrs Cameron declined, maintaining that 'no woman must
be photographed between the ages of 18 and 70'.[2] This often quoted
opinion ignores the fact that much of Julia's work featured women
in their twenties and thirties, if not older. Models such as May
Prinsep and Mary Hillier may have started their modelling careers
in their early teens, but they were still posing regularly for Julia
a decade later. This also neglects the models who were well into
adult life when they sat before Julia's lens, most notably Caroline

1. Hallam Tennyson continued this tradition when he became the lord of Farringford.
Nottingham Evening Post, 5 November 1915.
2. Emma Darwin, *A Century Of Family Letters 1792–1896,* vol. II (London: John
Murray, 1915), p. 190.

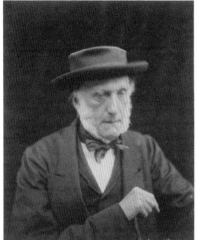 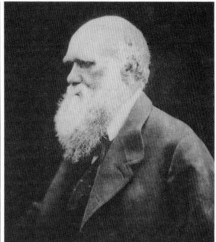

LEFT: *Erasmus Darwin* (1868) Julia Margaret Cameron
RIGHT: *Charles Darwin* (1868) Julia Margaret Cameron

Herschel, the eldest daughter of Sir John, who was thirty-seven years old at the time of her portrait. Not only portraiture featured older subjects: Anne Frederica Charteris, Lady Elcho, posed as *A Dantesque Vision* and *A Cumaean Sibyl* in 1865 when she was in her forties. While undoubtedly Julia favoured the beautiful young women who surrounded her, she was capable of variation. She might also have been aware of this reputation, as in her image of her young niece May Prinsep as a grandmother in *Acting Grandmama* (1866), a quote from a Tennyson poem.

At first the Darwins were rather bored in the peace of the island, but by August the charm and madness of Julia and her friends had worked their magic. Emma wrote to her Aunt Fanny about a visit in the rain to Farringford, where Tennyson greeted them with light wine 'to correct the wet'. The relationship between the poet and the photographer is obvious in the vignette of the party in the garden afterwards: 'Tennyson came out with us and shewed us all about, and one likes him, and his absurd talk is a sort of flirtation with

Acting Grandmama (1866) Julia Margaret Cameron

Mrs Cameron.' On the return to Sunnyside and Dimbola Lodge, the Darwins were well and truly won over by their host: 'We ended in a transport of affection with Mrs Cameron, Eras. calling over the stairs to her, "You have left eight persons deeply in love with you."' Despite not taking his photograph, Julia made a pet of young Horace who was roped in as a trainee assistant: 'The Madonna

[Mary] was often coming over, "Mrs Cameron's love and would Horace come over?" She wanted him to pack photos etc. …'[3]

Unquestionably the most unusual visitor to Dimbola Lodge was seven-year-old Prince Dejatch Alámayou of Abyssinia (present-day Ethiopia). He had been removed from his homeland after the suicide of his father, Theodore II, former ally of Britain, who had grown disillusioned with colonial rule. In the resultant heavy-handed war the king killed himself, leaving his son in the custody of the British, in the person of Captain Tristram Speedy. On his arrival in England the young prince was summoned to Osborne House to meet Queen Victoria, and thence to meet Tennyson, Julia and Darwin in Freshwater. Julia took the opportunity to take a series of photographs of Speedy, the boy prince, and his attendant, Casa. According to pictures by other photographers Alámayou wore Western dress in England, but the images taken by Julia show all three of the party in full Abyssinian regalia, spear and all. In *Spear or Spare* (1868), a very uncomfortable Casa is threatened by Speedy in an act that could be interpreted as colonial dominance. However, Speedy is not dressed in Western, military clothes, but sports the exotic garb of the natives. This is not to say that the image is wholly without a colonial dimension. Speedy's choice of costume and willingness to act the part of a fellow tribesman does not detract from the fact that he was part of the colonial power that resulted in the death of Alámayou's father. Despite having international significance, *Spear or Spare* shares much of its sentiment with images of Mary Ryan, Julia's little Irish beggar, the kindest reading of which would be maternalistic rather than imperialistic. The images of the little prince, although a novelty, did not long distract Julia from her favourite theme. William Allingham, visiting the Cameron home on 21 August 1868, recorded the visit by the young prince, and the subsequent photographs where Speedy in lion-skin tippet, sporting a huge, hook-shaped Abyssinian sword – 'point goes into your skull' –

3. ibid., p. 191.

Dejátch Álámáyou, King Theodore's Son (July 1868) Julia Margaret Cameron

grumbled at being posed. As soon as that was finished, Sophia Hillier was summoned to pose as 'Desdemona', the excitement and tragedy of a colonial war no match for the beauty of a Freshwater girl.[4]

With a large heart and a fear of an empty nest, Julia was not averse to bringing more children into her household to replace her own offspring, now grown and flown. Mary Ryan had been scooped into Julia's embrace, but was allowed to leave on the arm of Henry Cotton, a young man of good prospects who had fallen in love with her via Mrs Cameron's photographs. She had left in 1867, and Julia wrote a sad letter to William Michael Rossetti complaining that 'for the first time in 26 years I am left without a child under my roof – but they are all doing well and struggling to improve and I must not grudge the sacrifice of their sweet society'. That was not entirely true, as Julia continued to acquire adopted children. Dimbola Lodge was again filled with beautiful girls who took refuge in Julia's home and posed for the camera. Cyllena Wilson was the granddaughter of Samuel Sheridan Wilson, a missionary, minister and translator of the New Testament into modern Greek. He was the author of many books about his travels around the world spreading the Good Word with his wife, and their numerous children were born on their various travels. Arthur Michael Wilson was one of their middle children, born in Malta in 1826. He in turn married the wonderfully named Cyllena Butters from Devon in 1850. Their children – Cyllena Margaret, Melita Emily and Alfred – were born in the 1850s, but in swift succession the children's grandfather, father and mother died. Julia had been a friend of Samuel and opened her house and heart to the three Wilson children. Cyllena began to appear in photographs in 1867 at the age of sixteen, and her broad, beautiful face was used to portray 'Rosealba', 'A Bacchante' and 'Vectis'. She posed together with Mary Hillier in two images inspired by figures on the Elgin Marbles (1867), but she did not enjoy being Julia's muse. Allegedly

4. Radford, *William Allingham: A Diary*, pp. 185–86.

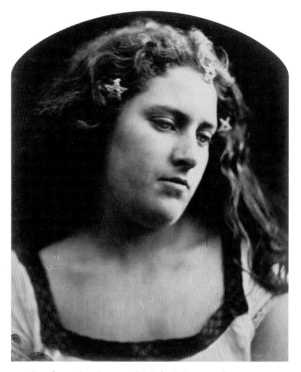

A Bacchante (20 June 1867) Julia Margaret Cameron

in order to get her model truly to express despair Julia locked the poor girl in a cupboard for two hours, but the resultant photograph of the distraught Cyllena has not been traced. Life in Freshwater was not what the girl wanted: she ran away, finding work as a stewardess in Southampton on a ship destined for New York.[5]

However, the presence of the incomers was not without friction for the residents. In November 1868 Mary Hillier's elder brother

5. Cyllena married the first engineer on the ship, but was widowed swiftly after returning to her husband's family in Falmouth, Cornwall. The wandering spirit came upon Cyllena again, and leaving her children in Falmouth she went to Argentina, where her family believed she had died of yellow fever. However, she appears in subsequent census returns, married once more.

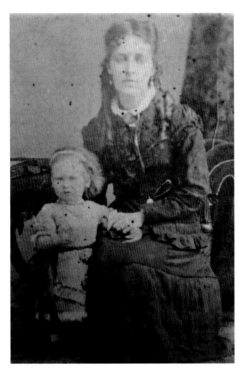

Cyllena and her youngest daughter Edith Mabel
(*c.* 1880) unknown photographer

William set fire to a plantation of trees at Farringford as a Bonfire Night 'lark'. After Mary Kellaway's cousin Samuel was arrested for the damage William went to Emily Tennyson to confess his crime. According to the newspaper report of the hearing Emily's kindness and 'promise of forgiveness' convinced William to come clean to the police. Due to the intervention of Lady Tennyson and the generally perplexing nature of the crime William was released, with only the costs of the court against him. William's explanation of just wanting a lark on Bonfire Night was accepted by the courts. In all likelihood, the choice of the Tennysons' wood was more to do with location than any ill-feeling, but it does raise questions

of the balance between gratitude and resentment between locals and incomers. An example of this occurred in February 1868 when local carpenter Jesse Adams was forced into bankruptcy, a matter reported in both local and national press. He attributed his failure and debts of £71 to entering into a contract with Julia Margaret Cameron, photographic artist. No other details of the case are available, but the bankruptcy of a local man through the actions of someone relatively recently arrived must have put the locally born servants, like Mary, in an awkward position. Mary's loyalties were tested by a more serious criminal action in 1873.

On 10 March Dimbola Lodge had been full of guests. As usual, Julia employed local men to wait at table on her friends. Henry Church, a jobbing labourer, had been brought in for just such an event, but during the evening Mary had seen the young man enter the pantry. She had thought little of it until a week later when she found that one of Mrs Cameron's crested silver spoons was missing, and raised the alarm. A theft in a household is a very serious matter and one that places the servants under suspicion; thefts by servants accounted for the largest total loss of property in the Metropolitan Police Area in 1837, and many a maid had been tempted into pilfering by the comparative wealth of her mistress.[6] However, they did not have to wait very long for the matter to be resolved. The same day that the spoon was missed at Dimbola Lodge, Henry Church was arrested at George Marriott's establishment across the water in Lymington for trying to sell Julia's teaspoon. Marriott, a silversmith and watchmaker, had been offered the spoon, which weighed only half an ounce, for a couple of shillings. Marriott's alert led to a charge of hawking without a licence, followed swiftly with the far more serious charge of theft. Church was placed in the hands of Superintendent Stephenson of the Isle of Wight Constabulary, who took the miscreant back over the Solent to Yarmouth to face the courts.

6. Frank Edward Huggett, *Life Below Stairs: Domestic Servants in England from Victorian Times* (New York: Scribner, 1977), p. 65.

Lymington High Street

Matters moved quickly, and on 26 March Church found himself in front of the County bench at Newport in a session that covered theft of hay (one day's imprisonment), theft of sugar (six weeks' hard labour) and non-vaccination of a child (£1 fine). When it came to Henry Church and the theft of the teaspoon, the court called Mary Hillier, maid to the Cameron household at Dimbola Lodge. Mary testified that Henry Church had been at Dimbola Lodge as help at table, and that she had seen him enter the pantry where the teaspoons were kept. Mary agreed that the teaspoon that Church had attempted to sell to Marriott was indeed the missing teaspoon, and Church was found guilty and sentenced to two months' hard labour. Once more Mary had been forced to choose between her mistress and her village, and her loyalty to her mistress had won.

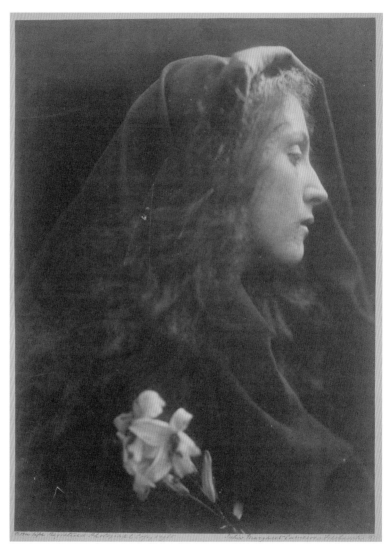

The Angel at the Sepulchre (1869–70) Julia Margaret Cameron

CHAPTER TEN

The Angel at the Tomb

TWO OTHER ARRIVALS IN THE CAMERON household had been the granddaughters of Julia's younger sister Adeline and her husband Colin Mackenzie. The girls, Mary and Adeline Clogstoun, were taken in after the death in 1862 of their father, Herbert Mackworth Clogstoun, a Victoria Cross recipient for his part in suppressing the Indian Rebellion of 1857–58, and their mother, Mary Julia, in 1870. Their sister Blanche lived with Sarah Prinsep and was eventually adopted by G. F. Watts. The addition of Mary and Adeline Clogstoun to the household rumpus was supplemented on a regular basis by Julia's own grandchildren, all of whom were called to serve as models for photographs. In a household already disrupted by the art of photography, the rambunctious play of little girls was tolerated. On 8 June 1872 the governess was ill, and the girls were unsupervised. Despite entreaties from Julia to play less roughly, the girls and Julia's granddaughter Beatrice continued to jump on each other's backs. With Adeline at the bottom, Blanche jumped on the back of Beatrice, who was already clinging to Adeline, and broke Adeline's spine. The child was taken to her room and there reclined unconscious with Mary and the children by her bedside in tears.

The devastation that this horrible accident brought to the household was not enough to stop the visit of Thomas Wentworth Higginson, a writer from America who had come to pay homage to the great Poet Laureate in Freshwater. In his memoir *Cheerful*

Yesterdays Higginson recorded a visit with Tennyson to Dimbola Lodge: 'We were ushered into the chamber, where a beautiful child lay unconscious upon the bed, with weeping girls around.'[1] After a solemn scene where Tennyson kissed the poor child's forehead, Julia took her guest downstairs and in typical fashion pressed photographs upon him, which he accepted with pleasure, choosing an image of Mary as the *Angel at the Sepulchre*, having just seen her guarding the bedside of the dying child upstairs. Adeline never recovered consciousness and died within a few days, leaving the household traumatised.[2] Julia described her horror, guilt and grief in a letter to Anne Thackeray: 'It has been like a mysterious dream losing that blossom of my old heart thus and in such a way!' Julia refused to have an autopsy:

> I did not after all have my darling opened tho' I felt sure it would all be confirmed – the Doctors all three thought so but for Blanche's sake I did not want it confirmed to darken her whole life! for Beatrice got on Addie's back & then Blanche with a spring from the couch bounded on the top of Beatrice's back so that fragile Addie had the double weight.[3]

Julia's response to the death of little Adeline was to present her as a saint in an upstairs bedroom. She set up her camera.

Images of a dead child seem distasteful to modern eyes, but in Victorian currency they were if not normal then certainly within the bounds of acceptable mourning that included fashioning jewellery from the hair of dead loved ones, and propping up the recently deceased to appear in one final family portrait. The photograph of Adeline Grace Clogstoun can be seen an extension of

1. Thomas Wentworth Higginson, *Cheerful Yesterdays* (Boston/New York: Houghton, Mifflin, 1901), p. 296.
2. ibid., pp. 296–97.
3. Quoted in Cox and Ford, *Julia Margaret Cameron*, pp. 69–70.

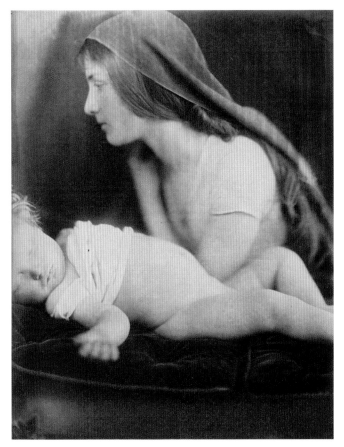

The Shunamite Woman and her Dead Son (1865) Julia Margaret Cameron

photographs such as *The Shunamite Woman and her Dead Son* (1865) showing Mary Ryan bowed in stoic grief over the form of Percy Keown. Just as in her translation of *Leonore*, Julia embraced the Gothic in her photography, taking inspiration from Tennyson's dead heroines such as the May Queen in *'If You're Waking Call Me Early, Call Me Early Mother Dear'* (1864), also modelled by Mary Ryan, and *The Death of Elaine* (1875). Arguably the composition

Study for Fading Away 'She Never Told Her Love' (1857) Henry Peach Robinson

of *The Shunamite Woman and her Dead Son* is no different from *La Madonna Riposta* (1864) which also features Percy Keown, or *My Grandchild Archie [Archibald Cameron, son of Eugene Cameron], Aged 2 years & 3 months* (1865), but Percy Keown and Archibald Cameron are sleeping and compliant rather than the 'sacred and lovely remains' of a dead child. Adeline's images, marked 'From death' on the prints,[4] became at once both religious and sentimental, and as staged as any death scene, such as Henry Peach Robinson's photographic *Fading Away* (1858), where a consumptive girl prettily expires between weeping women. Julia found process in dealing with her grief in both the taking of photographs and the offering of pictures to visitors. Death, and its image, become a spectacle that was processed visually for the mistress of the house.

4. As opposed to the normal 'From the Life'

Mary wept by the bedside, comforted other members of the household, assisted with the post-mortem photographs, and waited on guests who attended.

Julia took four photographs of the 'the sacred and lovely remains' of Adeline. Three are taken from the side of the bed against a black curtain that hides the other side of the room and her sister's bed. In the staging of the images Julia satisfied the more artistic aspects of photographing the dead. In an article later in the century about the practice, by then seen as 'undesirable' and always private, some justification is made, especially when images of doomed and dying characters like 'Elaine' were so popular in art. The only stipulation the author brings is that post-mortem images should be free of trappings such as coffins – 'the truth is then at once apparent and the disagreeable feelings alluded to arise'.[5] Adeline is stretched out on the bed, surrounded by flowers, appearing not unlike the sleeping children in Julia's photographs. In fact, in the

Study of a Dead Child (1872) Julia Margaret Cameron

5. *Swindon Advertiser and North Wilts Chronicle*, 4 September 1897.

photographs of Adeline Julia managed to amalgamate the spirit of her child photography and her images of beautiful women. As peaceful and pious of any image of Mary Hillier, the child apparently slumbers like baby Percy Keown or Archie Cameron, but the unnatural stiffness of the figure, the careful arrangement, and the feet incongruously poking from the nightgown unsettle the viewer as only an image of our own mortality can.

Little Adeline's demise was not the first death for Julia's Freshwater community. Rhapsodies of grief appeared in the press on the death in 1866 of the poet and translator Philip Stanhope Worsley. He had come to Freshwater for the sea air, saying at St Catherine's House and later Farringford, but a decade of ravage by tuberculosis had left him weak and he finally succumbed to the disease on 8 May. Only thirty years old, Worsley had been a rising intellectual star with his poetic translations of the *Odyssey* and the *Iliad* and was described in one obituary as 'a light that had but lately dawned on our horizon and gave promise of a bright day'.[6] His literary prowess would have been enough to attract Julia but it was coupled with good looks, albeit ones that had suffered from his disease. While nursing him in Tennyson's home, Julia brought her camera to his bedside and took a startling image of the dying poet. His thin head glares defiantly from his pillow, the sunlight catching the angles of his face. Not quite a post-mortem photograph, but one decidedly of a man facing death. On 4 February 1871 Charles Cameron's sister Isabella Hay Darling died while visiting Dimbola Lodge. At the age of eighty, this was not surprising, but again it would be left to Julia and her maids to handle the business of a death in the house.

Adeline Clogstoun's death tainted Julia's love of her home, at least for a while, and possibly Charles Cameron took it as an opportunity to convince his wife once more that they should return to Ceylon and their coffee plantations. Cameron obviously

6. *Glasgow Evening Citizen*, 19 May 1866.

Philip Stanhope Worsley (1866) Julia Margaret Cameron

harboured romantic notions of the island, and one by one their sons had gone to live on the family plantations. The cost of keeping a home in England as well as the plantations was an expense that the Camerons struggled to afford, despite Julia's hopes that the sale of her photographs would supplement their income. Coupled with this, the separation from her sons always caused Julia stress, and it seems evident that the tragedy of Adeline Clogstoun unsettled Julia to the point of departure. A matter of weeks after Adeline's death, advertisements for Dimbola Lodge appeared in the London *Evening Standard* in June 1872:

> To be LET, FURNISHED, Freshwater Bay, Isle of Wight, a HOUSE with a full view of the open sea and downs; has nine bed rooms, three sitting rooms, croquet lawn and pleasure lawn; within a few yards of post office and telegraph office. Also a house, Furnished, with four-bedrooms and two sitting-rooms close to the sea but not having a view of the sea – For particulars of both these houses apply to Mrs Charles Cameron, Dimbola Lodge, Freshwater Bay, Isle of Wight.[7]

Either no one applied, or by the time any interest was shown Julia had lost the impetus to flee the island. She would remain in Freshwater for a few more years.

7. The emphasis placed on the post and telegraph offices suggests that Julia might have been responsible for drafting the advertisement as well as being the point of contact, as she prized communication with her loved ones so highly.

Long Suffering

IN 1873 THE PRINSEPS lost the lease on Little Holland House and began plans to move to Freshwater. George Frederic Watts struck up plans to build a home for them all on land bought by Thoby Prinsep. He commissioned Philip Webb to design a new studio-house not far from Farringford and Dimbola Lodge.[1] Laura Troubridge described it as 'a three storied building in red and white, half villa, half cottage, yet wholly delightful, and he called it "The Briary," because of the masses of sweetbriar that grew wild everywhere.'[2] Webb, wishing to save Watts money in what was bound to be an expensive venture, brought in a trusted builder, John Tyerman, who had previously worked on similar artists' houses with Webb before. This incited jealousy among the Freshwater builders, resulting in complaints made to Julia that work was not being conducted well. She conveyed this worrying news to Watts, who in turn stormed at Webb. The house was nonetheless finished, despite the war of words on both sides, but Webb felt so affected that he refused to take a fee from Watts.[3] The house was felt to be one of the most beautiful on the island, with echoes of

1. Caroline Dakers, *The Holland Park Circle: Artists and Victorian Society* (New Haven/London: Yale University Press, 1999), p. 150.
2. Troubridge, *Memories and Reflections*, p. 20. The house was originally called 'Myddleton Priory', but the name was changed to reflect the gardens.
3. Sheila Kirk, *Philip Webb: Pioneer of Arts and Craft Architecture* (Chichester: Wiley, 2005), pp. 77–78.

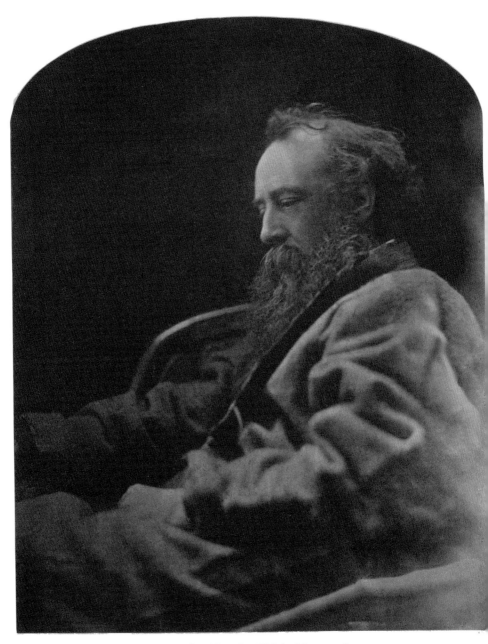

George Frederic Watts (1864) Julia Margaret Cameron

both Italy and India, reflecting the spiritual homelands of Watts and the Prinseps.[4]

Juley's health after the birth of her sixth child, Herman, in June 1872 worsened after years of miscarriages and births. In October 1873 she died, leaving Julia in a state of stoic grief, yet frantic over the fate of her son Henry, who had given up his chosen profession of acting in order to join his brothers at the plantations in Ceylon. The comings and goings of her sons weighed heavier on her than her only daughter's death, to which she was not blind, writing to a friend that 'the departure of my Benjamin, of my youngest son Henry Herschel Hay I felt even more acutely than I did my daughter's death. This might seem to some unnatural but it was natural to me – even much as I cherished my daughter my youngest son had kept so close to me thro' all my severest trials.' The loss of her daughter had arguably happened many years before Juley's death, as Julia seemed to grow apart from Juley after she married Norman. The sons on the other hand left and returned to their mother regularly.

Henry Herschel Hay Cameron (*c.* 1870)
Julia Margaret Cameron

To the disgust and shock of her family, Julia once again sought escape through photography. This time she did not seek a post-mortem record of her daughter's death, but as Juley had perished in Kent and had a grieving husband as gatekeeper it was not the same scenario as the death of Adeline Clogstoun. Julia's preparations for her exhibition at Colnaghi's

4. The original house was destroyed by fire in 1934.

Gallery in London, opening a month after Juley's death, filled her sister Mia with horror: 'I cannot understand her doing such a thing at such a time – She is evidently bent upon carrying it out & therefore has not mentioned it to any of us for she knows what we must feel.'[5] Whatever Julia's feelings about her daughter's death might have been, the prospect of a failing coffee harvest and mounting costs made the exhibition a necessity, and so rather than take further images Julia concentrated on marketing and selling existing ones. It was not that she was mercenary or careless of the feelings of her family: she never lost sight of the precarious financial position the Camerons occupied.

For the precious sons, a potential daughter-in-law was Annie Chinery, born at the beginning of 1851 in the town of Lymington, just across the water on the mainland, from where the Camerons would sail to reach Yarmouth and Freshwater. She was the second daughter and youngest child of Edward Chinery, the town doctor. Julia was overjoyed with Annie when her son Ewen brought her to Freshwater: 'Never was one's own offspring dearer to a Mother than this darling daughter is to me', she wrote to Herschel. Annie was

> perfectly unconscious of her beauty – only 18 – naive, ingenuous and steadfast, strong and utterly true and reliable. She adored her own father Dr Chinery and he had nothing in life he loves so well as this Ewe Lamb of his flock – but yet she surrendered herself to Ewen and started with him for his mountain solitude [in Ceylon] without a misgiving tho' of course it was a severe trial to leave her home.[6]

It could however be argued that Annie looks cautious in images such as *The Bride* (1869). The photograph implies that it is the actual day

5. Unpublished letter, quoted in Olsen, *From Life*, p. 230.
6. Unpublished letter, quoted in Wolf, *Julia Margaret Cameron's Women*, p. 220.

The Bride (1869) Julia Margaret Cameron

of the wedding, and if that is to be believed Julia made Annie pose and wait for however long it took to capture an image when the girl was on the way to the altar – as if to possess her artistically before she became her son's wife. The image foreshadows spirit photographs, as Julia swirled the developing fluids to make the swirls of veil, and Annie appears to the viewer as a spirit conjured out of the mists to answer her mother-in-law's prayers. Other photographs of the girl

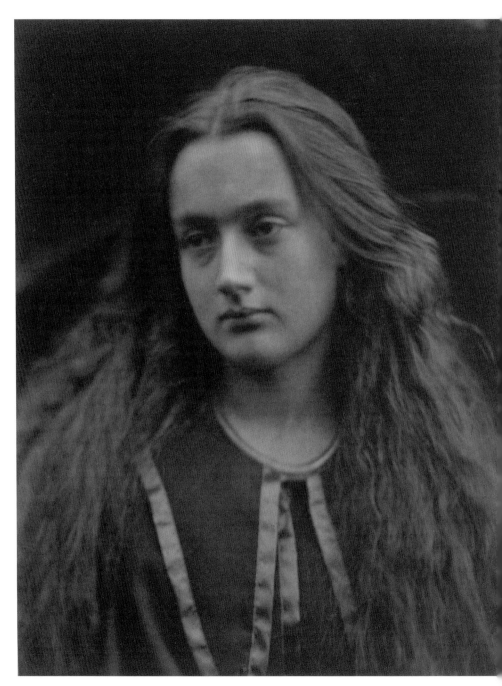

God's Gift to Us or *My Ewen's Bride* (1869) Julia Margaret Cameron

echo this intensity, labelling Annie as *'God's Gift to Us'* (1869).

Julia's fixation with Annie Chinery is in direct contrast to the cool relationship that she had with her son Eugene's wife, Caroline, who never appeared in any photographs, although there is a flurry of images of the couple's son, Archibald. The sleeping child appears in a collection of images resulting from a visit in 1865, when Archibald is pictured in photographs such as *My Grandchild Archie, Aged 2 years & 3 months*

Eugene Hay Cameron (1867)
Julia Margaret Cameron

(1865). He also served as the Christ Child, with Mary Hillier as the Madonna, in *The Shadow of the Cross* (August 1865) and *Devotion* (1865). The couple's daughter Beatrice, unhappily present at the death of Adeline, also modelled for one of Julia's archetypal praying children. Eugene is only present in two known images, unlike Julia's other children; this might be read as symptomatic of Julia withholding love, however unhappily, from her son, who did not allow her as much access to his life as she demanded.

For those Julia held in her heart and before her lens, Annie was a star. She wrote to Herschel:

> Her brow is smooth and white + as you see very lofty. Her hair golden brown – so brown + yet so richly burnished with gold – her skin very fine + enamelled but decidedly dark ... a carnation rich red colour – bright hazel eyes very soft + liquid with a sweeping fringe of very dark lashes + dark eyebrows very finely chiselled nose + the most exquisite mouth (of this you can see the record) a

> very slender figure with roundness + embonpoint height
> 5 foot 7 + fairy hands and feet.[7]

Ewen and Annie bought a coffee plantation near the Camerons', causing Julia to exclaim in delight, 'Every hour of every day I rejoice in the pure and happy marriage which has secured to Ewen his Treasure.'[8] But the newlyweds found themselves called upon to assist with the finances of their parents' plantations as well as their own. The life of a colonial wife was not for Annie, and rather than sending her children back to English relatives while she remained by her husband's side she returned with her children to Lymington, and did not seek a close bond with her mother-in-law. What Julia required from the young women in her life was the certainty of subordination that only a servant can offer. Annie posed infrequently for her, living apart from Ewen and his family for the greater part of their marriage. Mary on the other hand would never seek such separation, and so continued to provide inspiration for her mistress. Julia expressed this most expansively in the writing of *Annals of My Glasshouse* in 1874.

7. Unpublished letter from Julia to Herschel, 6 February 1870, quoted in Olsen, *From Life*, p. 218.
8. Weaver, *Whisper of the Muse: The Overstone Album and other Photographs*, p. 65.

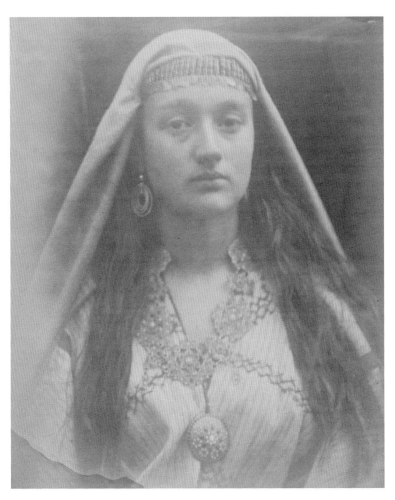

Balaustion (Annie Chinery) (October 1871) Julia Margaret Cameron

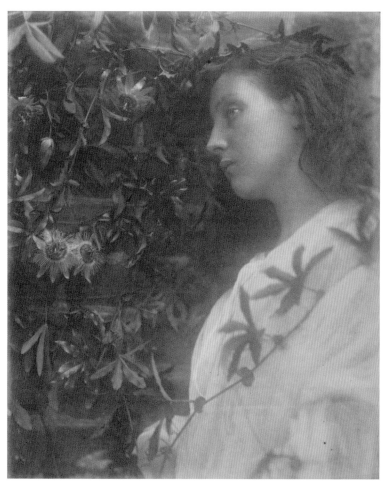

Maud (1875) Julia Margaret Cameron

Call, I Follow, I Follow, Let Me Die

A DECADE AFTER THE GIFT of her first camera, Julia's autobiography, *Annals of My Glasshouse*, has the air of reclaiming the narrative of her life and career. No mention is given to the tutelage by other photographers, more of her own struggles to 'arrest all beauty that came before me', finding her method through trial and error rather than the advice of the practitioners she paid to take photographs in her company. The first hints of Mary come in the praise for the people of the Isle of Wight – 'The peasantry of our island is very handsome. From the men, the women, the maidens and the children I have had lovely subjects, as all the patrons of my photography know.'[1] From the outset, Mary's subordination to Julia is highlighted in the word 'peasantry', demarcating the people of Freshwater from the more-worldly 'incomers'. Labelling the inhabitants of Freshwater as 'peasantry', no matter how handsome, reveals how clearly Julia's relationships were governed by class.

Julia lists her first exhibited successes as including Mary Hillier in her familiar role of Virgin, *La Madonna Aspettante* (1865), an image that 'cannot be surpassed'. Her pride over the marriage of Mary Ryan is nothing to her lyrical praise of Mary Hillier, who

> from early girlhood has been one of the most beautiful
> and constant of my models, and in every manner of form

1. Cameron, Woolf and Fry, *Julia Margaret Cameron*, pp. 48–49.

has her face been reproduced, yet never has it been felt that the grace of the fashion of it has perished. This last autumn her head illustrating the exquisite Maud –

There has fallen a splendid tear

From the passion flower at the gate,

is as pure and perfect in outline as were my Madonna Studies ten years ago, with ten times added pathos in the expression. The very unusual attributes of her character and complexion of her mind, if I may so call it, deserve mention in due time, and are the wonder of those whose life is blended with ours as intimate friends of the house.[2]

It is Mary's beauty and constancy as a model that draws Julia to write, finding inspiration in her after a decade that speaks to the very early images she captured. Arguably the improvement in Julia's skill, as demonstrated by the head of *Maud* (1875), enabled her to express the inspiration offered by Mary in poses other than cowled and clutching a baby. Possibly the lack of babies also pressed Mary into other roles, the Keown children having grown up and Freddy Gould destined for a life in service away from the island.[3] The image of the tearful Maud marks the pinnacle in Julia's relationship with Tennyson and his poetry, as the photograph was made into the frontispiece of a cabinet edition of the poet's works. But disgusted by the small size and the quality of the image Julia rebelled, and planned her own majestic folios of Tennyson's work with full size original photographs. These *Idylls* were to be

Frontispiece from the cabinet edition of Tennyson's *Maud and Enoch Arden* (1878)

2. ibid., pp. 56–59.

3. However, Freddy returned to Freshwater in the new century after training as a bricklayer and marrying a girl from Lymington.

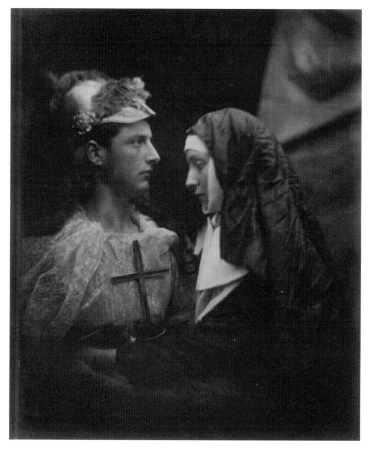

Sir Galahad and the Pale Nun (1874) Julia Margaret Cameron

Julia's final major works. They include Mary in various roles, including handmaid to King Arthur and the visionary sister of Sir Percival in *Sir Galahad and the Pale Nun*.

The following year, 1875, brought Julia's final foray into poetry as well, subsequently published in *Macmillan's Magazine* in February of the following year. The poem 'On a Portrait' is a love song to the power of art and the relationship of an artist to her subject:

Oh, mystery of Beauty! Who can tell
Thy mighty influence? Who can best descry
How secret, swift, and subtle is the spell
Wherein the music of thy voice doth lie?

Here we have eyes so full of fervent love,
That but for lids behind which sorrow's touch
Doth press and linger, one could almost prove
That Earth had loved her favourite over much.

A mouth where silence seems to gather strength
From lips so gently closed, that almost say,
'Ask not my story, lest you hear at length
Of sorrows where sweet hope has lost its way.'

And yet the head is borne so proudly high,
The soft round cheek so splendid in its bloom,
True courage rises thro' the brilliant eye,
And great resolve comes flashing thro' the gloom.

Oh, noble painter! More than genius goes
To search the key-note of those melodies,
To find the depths of all those tragic woes,
Tune thy song right and paint rare harmonies.

Genius and love have each fulfilled their part,
And both unite with force and equal grace,
Whilst all that we love best in classic art
Is stamped for ever on the immortal face.[4]

The poem is dated September 1875, just as Julia was preparing to move to Ceylon. The poem could have been inspired by any of

4. *Macmillan's Magazine*, vol. 33 (1876), p. 372.

the girls who had posed for Julia, but coupled with the deep bond expressed by Julia for Mary in her *Annals* it is equally likely to be a parting celebration for a girl from a small corner of the Isle of Freshwater.

In 1869 *Hermileia vastatrix,* the dreaded coffee leaf rust, first appeared in Ceylon and virtually wiped out the plantations in a few years, just as the market in Latin America was taking off.[5] However, in a letter to *The Northern Whig* of Belfast in 1875, the virtue of investment in the Ceylonese coffee market was expounded, with no mention of the ongoing problems:

> coffee planters of Ceylon at this moment are enjoying the exuberance of triumph, which a full tide of commercial success always brings with it … Prices which three or four years ago would have been magnificent are now insignificant. Ninety shillings per cwt [hundredweight] was then a heaven of glory, whereas now the minds of coffee heroes soar to a hundred and twenty.[6]

The valley of Dimbola was particularly singled out for praise, where you could see coffee 'in all its glory' – but if the market was flourishing so well, why were the Camerons always so anguished over money? The fact that the piece was written by Anthony Trollope just over a decade after he had posed for one of Julia's portraits might go some way to explain the piece of blatant propaganda to encourage investment. Charles Cameron was now eighty years old, and journeying to and fro to Ceylon to manage his lands was no longer an option. He confided to Henry Taylor that he wanted Ceylon to be his final resting place, and as his health deteriorated that reality appeared to be coming nearer. With all four sons now settled in their work at the plantations and Charles's health and

5. Pendergrast, *Uncommon Grounds: The History of Coffee*, p. 43.
6. *The Northern Whig*, Belfast, 7 August 1875.

happiness in her heart, Julia made the difficult decision to leave Freshwater forever.

Julia's own health had also suffered, and the anxiety she felt whenever she parted from her sons manifested as bronchitis. Faced with the choice of being parted from her sons or being parted from her friends, she chose the latter. The houses were featured once more in a long and descriptive advertisement, this time for sale by private contract:

> the houses are most desirably placed for a gentleman's residence or well adapted for a high-class school, or for a first rate boarding house, being connected internally, and can be occupied together or separately; they contain five spacious reception-rooms and 20 principal and secondary bed-rooms and excellent offices; a detached building in the lawn has been used as a theatre or lecture-room, and is well suited for a gallery or billiard-room; the pleasure grounds are prettily disposed in croquet and tennis lawn, and are well planted with choice evergreen and other trees; there is stabling accommodation, and the supply of water is good: immediate possession may be had.[7]

Again, what mattered to Julia at Dimbola Lodge shines through in the advertisement – amateur dramatics and the water supply. Passage was booked for 21 October 1875 from Southampton. With them the Camerons took their maid Ellen Ottignon and Mary Clogstoun, Julia's surviving great-niece. Belongings were crowded into two coffins used as packing cases for the journey, a seemingly macabre nod to the fact that this was very definitely the couple's last journey. There was no question that perfectly decent coffins could have been acquired in Ceylon, but once more Julia's fear of

7. *The Standard*, 15 July 1875.

My Beloved Son (Hardinge Hay Cameron) (1871) Julia Margaret Cameron

sea voyages, which saw both her mother and sisters die in transit, resurfaced in a practical manner.[8] Right up to departure Julia was frantic with work, printing and circulating photographs, no doubt with Mary at her side and in her thoughts, as she expressed her regret at leaving behind so many people. She wrote in a letter to a friend on 6 September 1875: 'What this move means to me you can as well imagine as I can describe to bid farewell to all my sisters, my grandchildren & beloved relations and friends – to give up this home that I have created for my children at such a cost.'[9]

The night before the journey was spent at Radley's Hotel in Southampton, on the corner of Terminus Terrace and Queen's Terrace, not far from the dock and the P&O ship SS *Mizapore*. In attendance were a few friends, none mentioned in accounts other than Lady Somers, who presented her departing sister with a cow for milk during the journey. The Camerons departed, Charles carrying a pink rose given to him by Emily Tennyson. The journey had barely commenced before Julia, unable to control her desire to do good to all she met, had raised a subscription list among the passengers to buy the ship's captain a harmonium to enhance the Sunday services at sea.[10]

A month-long sea journey followed to Galle in the south-west of Ceylon, arriving on the morning of Saturday 20 November. The coffins, carefully packed with the Camerons' belongings, were lowered to the teeming dock, among the tradesmen, planters and civil servants. Hardinge may have been responsible for arranging his parents' trip overland to his home, Kalutara, on the south-

8. Death on sea voyages was not unusual as it was the primary means of transportation between continents. Lionel Tennyson, younger son of the Poet Laureate, died on his journey home after contracting malaria in India. Eugene Cameron also perished at sea in 1885, but his death was the result of a fire on board a ship returning to England from the West Indies.

9. Unpublished letter, quoted in Julia Margaret Cameron Trust *Newsletter*, no. 17, Winter 1996–97.

10. Hill, *Julia Margaret Cameron*, p. 149.

west coast and then on to their home in the highland plantation in the mountains of the south of the island. The journey was 45 miles from the port – a sizeable journey for the elderly Charles and their goods and chattels, but Julia had arrived at an island that was home to her beloved sons, and that was everything she wanted. To finally be with Ewen, who was based in the Camerons' plantation in Rathoongodde which he now owned, and Charlie Hay and Henry Herschel Hay Cameron who had just bought their own estate called Lippakelle.[11]

One of the few recollections of the Camerons in Ceylon comes from the artist Marianne North in her *Recollections of a Happy Life* (1893). Despite his old age and ill health before their move, the colonial climate agreed with Charles Cameron. North described him as 'perfectly upright, with long white hair over his shoulders. He read all day long, taking walks round and round the verandah at Kalutara with a long staff in his hand, perfectly happy, and ready to enjoy any joke and enter into any talk which went on around him.'[12] This was quite a turnaround for a man who lived for his only wish, to die in Ceylon. The house itself was definitely a tonic for him. It stood on a hill overlooking the Kalu Ganga river that ran into the sea a quarter of a mile away. In the description given by Marianne North it sounds like paradise: 'It was surrounded by cocoa-nuts, casuarinas, mangos and breadfruit trees, tame rabbits, squirrels and mainah-birds [*sic*] ran in and out without the slightest fear, while a beautiful tame stag guarded the entrance; monkeys with grey whiskers and all sorts of fowls, were outside.'[13]

If the move was intended to settle Julia's nerves about the welfare of her children, it did not quite work. Hardinge, now seeking a path in the colonial civil service as private secretary to the Governor, was well liked in the neighbourhood, conversing with the locals in

11. Olsen, *Julia Margaret Cameron*, p. 248
12. North, *Recollections of a Happy Life*, p. 314.
13. ibid.

Marianne North in Mrs Cameron's house in Ceylon
(1877) Julia Margaret Cameron

Tamil. Julia's pride was, as always, tinged with anxiety, and she was alarmed as he worked hard to prevent the spread of cholera in local affected areas. Again, as a way of staving off the worry, Julia kept busy, and when Marianne North stayed with the Camerons there was plenty of evidence of photographic industry. She found herself the subject of some studies: Julia 'made up her mind at once she

would photograph me, and for three days she kept herself in a fever of excitement about it.' The description of Julia's process echoes the years in Freshwater:

> She dressed me up in flowing draperies of cashmere wool, let down my hair, and made me stand with spiky cocoa-nut branches running into my head, the noonday sun's rays dodging my eyes between the leaves as a slight breeze moved them and told me to look perfectly natural (with a thermometer standing at 96°)![14]

Despite the unsatisfactory results of the sittings, Marianne North used the portrait as the frontispiece to her memoirs.

Away from the Marys, and the cream of literary society, the locals in Julia's new Freshwater became her muses. She convinced

LEFT: *Ceylonese Woman* (1878) Julia Margaret Cameron
RIGHT: *Untitled Ceylon* (1875–79) Julia Margaret Cameron

14. ibid., p. 315.

Ceylonese Group by a Tree (1878) Julia Margaret Cameron

Hardinge to retain the services of a gardener who had a well-muscled back, 'though [Julia] had no garden and he did not know even the meaning of the word [in English]' On the mount of *Ceylonese Group by a Tree* Julia wrote: 'The girl is twelve, the old man says he is her father and is one hundred years old!' To help her in her cluttered house-cum-darkroom Julia had the devotion of her maid, Ellen Ottignon, or 'Little E' as she was known, 'who made herself quite happy, and helped her mistress unselfishly and devotedly'.[15]

With her mistress gone, back in England Mary's life became empty of purpose and occupation for the first time since she was fourteen. She continued modelling, but had foregone the business of getting married until Julia had left the country. When Julia returned just once more in 1878, for a visit described by her as 'a visit of turmoil, sickness, sorrows, marriages and deaths',[16] she found her beloved maid happily married, and settled at the Briary. A matter of pressing concern for Julia was the remarriage of her beloved niece Julia Jackson, who had been widowed young. Some attempts were made to match her with Charles Norman, Juley's widower, which both parties resisted; after refusing her other suitors, Julia married Leslie Stephen, the widowered son-in-law of William Makepeace Thackeray. The death that prompted the visit was that of Julia's beloved brother-in-law Thoby Prinsep on 11 February 1878 in the Briary. Mary was married to Watts's gardener Tom Gilbert, and already pregnant with the couple's first child. Having missed the couple's wedding in the winter of 1877, Julia presented Mary with a gift of some Ceylonese silver jewellery[17] before departing again for Ceylon.

In January 1879 Julia was taken ill while staying with her youngest son, Henry Herschel, an aspiring photographer, at the family's

15. ibid., p. 316.
16. Hill, *Julia Margaret Cameron*, p. 153.
17. Now in the collection of the Julia Margaret Cameron Museum in Dimbola Lodge.

bungalow, Glencairn, in the Dikoya Valley. Henry moved her sickbed so she could see the night sky from her balcony. 'Beautiful', she whispered – her last word. Her sons sent news of her passing home to the Isle of Wight: 'as the day died on Sunday, January 26th, the sweet, tender, gracious spirit of our beloved mother passed away in peace. No death could have been more calm, more beautiful than this.'[18] Her body was taken on a cart drawn by white oxen to a churchyard in the valley between Colombo and Galle. In May of the following year Charles joined his wife, as their sons reported: 'my dearest father left us, and, I hope, rejoined my dear mother in the spirit-world. When Death impresses his sign-manual on any countenance he gives it great dignity. But his face, so noble and intellectual in life, looked perfectly sublime.'[19]

The Camerons were much mourned by their family and friends back in England. Julia left a legacy of love, of what Tennyson referred to as her 'wild-beaming benevolence',[20] best expressed in one of her final letters home: 'Let me throw arms of memory around you *all*, and, if arms of memory, they must be arms of love.'[21]

18. Quoted in Hill, *Julia Margaret Cameron*, p. 154.
19. ibid.
20. Alfred Tennyson, *The Letters of Alfred Tennyson 1851–1870*, ed. Cecil Y. Lang and Edgar Finley Shannon (Cambridge, Mass.: Harvard University Press, 1987), p. 129.
21. Quoted in Hill, *Julia Margaret Cameron*, p. 148.

Charles Hay Cameron (1864) Julia Margaret Cameron

Mary Hillier (1864–66)
Julia Margaret Cameron

Mary after Julia

To make a print, the paper that will receive the image has to be prepared in advance. A mixture of egg white with a salt solution, sensitised with silver nitrate, is applied to the paper; when it is dry, the paper is ready. Then all that is required is for the paper to be placed against the glass negative in sunlight.

Depending on the sunlight, for an image to emerge can take from a few minutes to hours. You must be watchful, however, and not miss the moment when your picture reaches its ideal. The image would remain true, but exposure to too much light might make it fade to nothing. The paper is then fixed in sodium thiosulphate and washed to stop any further reaction. As long as the negative survives, more prints can be made. The fleeting moment can be reproduced forever.

A Study of the Holy Family

Life without Julia must have been a difficult change for Mary, who had spent her adult life, not to mention part of her childhood, in service to her unorthodox mistress. Mary's transition from servant to wife was comparatively smooth, and it is possible that she earned a little money in the meantime acting as a model for George Frederick Watts when he was living at the Briary. He painted Mary Hillier in a now lost painting entitled *Fair Daffodils*, and possibly in further canvases including *Charity*, based on Julia's photograph of Mary as the Madonna. Her sister Sophia, by contrast, was not able to move from a life in service to a life at home. The Tennysons retained her as a cook. For a short period in the 1870s she worked for the Liberal MP John Stapleton in his Kensington home. In 1879 Sophia returned to Freshwater to be married to John Richard Page, a servant born in Hampshire, just across the water from the Wight. She was again employed by the Tennysons as their cook, often in their London home. This meant she did not live with her husband, although they may have shared some sort of married life, if only briefly, as he was also employed as a servant in London for a while. He died in the 1890s and Sophia died in 1906, retiring shortly before her death back to Freshwater, where she is buried in the graveyard of All Saints' Church with her parents and siblings. Her husband is buried elsewhere. Something as simple as a lack of money kept two working people apart, despite their marriage, to the point of estrangement.

Mary's husband, Tom Gilbert, was not a native of Freshwater: his family came from the Wiltshire village of Broad Hinton, in the middle of Salisbury Plain. His father, Thomas, unusually did not go into agricultural labour or domestic service: he became the village policeman. At the age of twenty-three, he married Margery Carter, a girl from the nearby village of Netheravon, in the winter of 1847, which was swiftly followed by the birth of their eldest son, Tom, in 1848. The 1850s brought more children and a further move, this time across the Solent to the Isle of Wight. Their fifth child, Margery, was born on the island in 1857 in Brading, and the family finally settled at School Green in Freshwater, where they were recorded on the 1861 census.

School Green, Freshwater

Thomas Gilbert appeared in the local press for his attempts to uphold the law on the island. One report, from July 1861, told the story of his arrest of William Groves for stealing a duck at Colwell Bay on the west coast of the Wight. On boarding the small coastal *Sans Souci* to apprehend him Gilbert was assaulted by Groves and his friend Benjamin Lea. Lea was fined for the assault, but

despite being implicated in the matter of the duck, the evidence was insubstantial and it remained an unsolved case. In 1862, under the headline 'I'VE LOST MY SPOTTED COW', the court heard testimony from Gilbert on the case of a man begging for money to help him buy a new cow after the loss of his previous animal, using a forged letter of recommendation allegedly from the vicar of Newport. It was revealed that John Nicholson, the accused, never owned a cow; the 5 pence he had obtained earned him a month's hard labour.

Gilbert's children did not become agricultural labourers either. Two of his sons became gardeners, and another became a greengrocer. Tom, the eldest, became the gardener for Watts at the Briary. From Laura Troubridge's memories, the garden was a veritable Eden: 'There were leafy glades formed by tall trees whose branches reached overhead; soft, blustering winds brought the tang of the sea to the garden, which was full of old-fashioned flowers, lavender and sweet geranium, and climbing white and yellow roses.'[1] It is uncertain when Mary met Tom, but as she sat for Watts as model it is likely that he saw her in the gardens of the Briary. Their meeting has a romance reminiscent of Tennyson's poem 'The Gardener's Daughter' (1842), where the beautiful rose is discovered by the narrator in a beautiful garden, described thus:

> A single stream of all her soft brown hair
> Pour'd on one side: the shadow of the flowers
> Stole all the golden gloss, and, wavering
> Lovingly lower, trembled on her waist

The marriage took place at All Saints' Church in Freshwater on 5 December 1877, two years after the departure of Julia. After the marriage Mary and Tom moved into the servants' accommodation at the Briary. It is unclear whether Mary continued to model for

1. Troubridge, *Memories and Reflections*, p. 20.

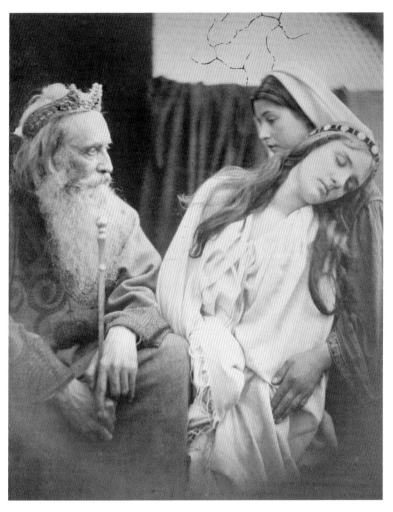

King Ahasuerus and Queen Esther in Apocrypha (1865) Julia Margaret Cameron

Watts after her marriage, but later in life she did recall posing for a painting of Lady Godiva, which she attributed to Sir Coutts Lindsay, artist and owner of the Grosvenor Gallery in London. As far as records show no such painting was produced by Lindsay, but Watts painted the subject in 1880, and the grouping of the swooning Lady Godiva and her servants bears a resemblance to *King Ahasuerus and Queen Esther in Apocrypha* (1865) so it is possible that Mary remembered the subject and forgot who was sketching her as she sat swathed in only a sheet.

When Julia returned in the summer of 1878 Mary was already pregnant with the couple's first child, who was born in December, by which time the Gilberts had moved from the Briary to Opawa in Moa Place,[2] not far from School Green. Mary's daughter was named after the most important woman in her life, Julia Mary. Either consciously or unconsciously, she had co-opted her daughter and by extension herself into the Pattles. Julia Mary Gilbert was aligned with Julia Jackson, daughter of Julia's sister Mia, as the inheritors of the Pattle line. In the April of 1880, Julia was joined by baby brother George Frederick Blackmore Gilbert, named for the artist whose house they had lived in, whose garden his father tended and whose canvases his mother had graced.

Tom was not the only gardener on the street: his neighbours William Jarry and Henry Fry both listed 'Gardener' as their occupation, signalling the establishment of incomers and their wealth in Freshwater. Towards the end of the century, however, Tom's occupation had become a little less certain. The death of Tennyson and the departure of Watts for his new home in Surrey marked the end of an era for Freshwater. The family had expanded to include Margery, born in 1882, Adeline Mary Rhyle, born in 1884, Thomas Harold Herbert, born in 1885, Ralph Denison, born in 1886, John William Rhyle, nicknamed 'Jobber', born in 1889,

2. The use of New Zealand place names in Freshwater is somewhat mysterious, but might refer to a history of emigration from one island to the other.

and the baby of the family, Godfrey Searle, born in 1891. Tom moved from being a jobbing gardener to a market gardener, selling the fruit and vegetables he grew to his neighbours in Freshwater.

George Frederick Gilbert trained to be a tailor, whereas Julia Mary went to a school at Chiddingfold in Surrey, nine miles from the village of Compton, where Watts and his new wife lived together with May Prinsep. That was not the only connection to Freshwater and the old days, as we shall see. Julia was a boarder in a school ostensibly for destitute children; her presence seems

Godfrey Searle Gilbert, c. 1900

incongruous until the history of the establishment is revealed. The home was run by Mrs Mary Hill, a widow from London, but she was not the institution's owner: that was Miss Emily Marion Ritchie, better known as 'Pinkie', and her partner, Edith Sichel.

Pinkie's life, while privileged, had not followed the pattern expected of a Victorian middle-class daughter. Its pattern was similar to that of Julia Margaret Cameron in many ways, albeit half a century later. Born in 1851, she was the third daughter of William Ritchie, who was Legal Member of the Council of the Governor General of India after the 'Mutiny'. Her childhood was spent mostly in Paris; the girls of the family lived a pleasingly scholastic, artistic life, immersed in music, books and paintings.

Pinkie's cousins on her father's side included Anne Thackeray. When Pinkie went to stay with Anne at Freshwater in the spring of 1870, Julia was quick to take the opportunity to capture her dignified beauty on a glass plate. Pinkie was a very handsome young woman with an impressive head of hair. During the spring that she and Anne were in Freshwater, Julia took an assortment

Emily 'Pinkie' Ritchie (1870) Julia Margaret Cameron

of photographs of both women, although Anne's always tended to be portraits, as befitting her status as a novelist. Pinkie appeared alone in images such as *And the Stars in her Hair were Seven*, taken from the Rossetti poem 'The Blessed Damozel', written in 1850 and republished in 1870, possibly inspiring Julia to use it as the subject. There seem to be no further images of Pinkie beyond May 1870, so either Julia had finished with her as a model or Pinkie did not frequent the island again while the Camerons were still in residence. It is during the trip in 1870 that Pinkie would have made the acquaintance of Mary Hillier, assisting both in the house and in the creation of the images.

Like many wealthy, unmarried women, Pinkie and her circle were interested in philanthropy. Just as Julia had 'adopted' Mary Ryan, to great success, Anne and her sister Minnie had taken home a little girl, Ellen, whom they had witnessed being hit in the street by her mother.[3] The largesse of intelligent, monied women, scholastically frustrated and unwilling to marry, needed direction, and in Mary Hillier it is likely that Pinkie saw an example of reward through service.

By 1884 Pinkie Ritchie, having twice escaped marriage, joined the collection of 'spare' women, tending to an invalid relative and dedicating her life to volunteering. What she joined was MABYS – the Metropolitan Association for Befriending Young Servants, where orphaned girls from inner city areas were taken in by 'respectable ladies' and set on a path of sensible servitude rather than predictable prostitution. That year was special for Pinkie. Much later, in her friend Edith Sichel's collected work that she had edited and privately printed in 1918, she wrote: 'It was when [Edith] was two-and-twenty, a few months after her father's death in 1884, that she and I first came into each other's lives ... It was a wonderful day when Edith, who had long wished for such work, but had not hitherto been free for anything of the kind, came to

3. Alison Light, *Mrs Woolf and the Servants* (London: Penguin, 2008), p. 97.

join me.'[4] Pinkie was thirty-three and Edith was twenty-two; both were talented, intelligent women, cultured and well read. They also shared a horror of the poor conditions in which families lived in the worst districts in London and a desire to do everything in their power to better the lives of the children in need.

When both Pinkie and Edith lost their mothers in 1888 they were finally free not only to move in together and live as a couple but also to enact their philanthropic desires in the form of Elm Cottages on Lincoln Hill in Chiddingfold. Mary Hill, the matron of the home, was assisted by her daughters Rosina and Florence. Julia Mary Gilbert, a 'scholar' there according to the 1891 census, was one of two older girls, at 13 years old, the other being Elizabeth Clark from the Whitechapel Workhouse. As Pinkie wrote later, 'There were no parents to claim them as they grew up, almost all rewarded her [Mary Hill's] care by becoming excellent young servants.' Edith wrote up her experiences with Pinkie in an article entitled 'The Confessions of an Amateur Philanthropist', published in the journal *New and Old*.[5] Julia Mary Gilbert was not an at-risk girl, so her presence in the home is a puzzle unless she was brought there as the archetype of what they were hoping to create. For Julia Margaret Cameron, Mary Hillier had been the perfect maid and the model of a respectable life modestly lived. This was the pattern which the girls that passed through the doors of Elm Cottages and the subsequent homes that Pinkie and Edith established were pressed to emulate. From the Chiddingfold school Julia Mary passed into her mother's profession, becoming a maid in the home of the wealthy barrister Francis Haviland of Branksome House, St Leonard's-on-Sea, on the south coast.

In Freshwater Margery Gilbert had followed her mother's example to the letter, becoming a maid in the village, while Adeline

4. Edith Sichel, *Letters, Verses and Other Writings*, ed. Emily Marion Ritchie (privately published, 1918), p. vi.

5. ibid., p. 44.

was in the household of Lady Marcia, daughter of the 3rd Marquess of Cholmondeley, in Dorset. The boys, Thomas, Ralph, John and Godfrey, were all sent to the new Local Education Authority school. Thomas was the focus of his mother's educational ambitions. She wanted him to learn, to rise further than she had, out of labouring and the uncertainty of seasonal physical work. On her shelves she had bound volumes of Tennyson's poems and a birthday book filled with his verses. She also had a home medical guide in which she quietly and determinedly read the causes of blindness as her vision grew weaker. She returned to the section so often that even now the book falls open there.[6]

George Frederick was not the only tailor in Freshwater at the turn of the century. Carl Josef Platte must have been a novelty in the village, although the Isle of Wight had always been a popular holiday destination for Germans. The young man must have been known to George Frederick and rapidly became known to

6. With thanks to Evie Hodgson for the loan of the collection of Mary's books.

Margery. The couple married on Christmas Eve 1903 and moved into a house in Station Road, where Carl – or Charles as he quickly became – kept his business as a tailor. He was well known in the area for his chickens, his Plymouth Rock cockerels winning prizes not only in the local shows but on the mainland, in Sussex, Surrey and Hampshire. However anti-German feeling had begun to fester, even in the beautiful western corner of the island. In 1908 the *Isle of Wight County Press* reported that the voting lists had been revised, and the name of Charles Platte, tailor, of Station-road had been struck out 'on the grounds that he was an alien – a German'.[7]

Adeline returned to Freshwater, joining her brothers in the family home once more. John had moved to London to be a grocer's assistant, but Ralph and Godfrey ran a cycle shop, building the bicycles themselves. Thomas had fulfilled his mother's wish and had become a schoolmaster. He was courting Ethel Kellaway, a milliner and cousin of Mary's fellow maid at Dimbola Lodge. Mary was the matriarch in the Gilbert family, promising to bring a new generation and happiness with education and family businesses to their name. The second Gilbert wedding, of Thomas and Ethel, should have been a joyous affair for the family, but it was rushed in August 1914. The war had broken out, and Freshwater families rich and poor would pay the price.

7. *Isle of Wight County Press*, 12 September 1908.

Mother and Child

Before the war was even declared anti-German feeling was running high on the Wight. A young woman holidaying on the island in July 1914 wrote in her diary: 'About this time there were a good many spies captured in the island, which is always overrun with Germans during the summer months, and there were one or two scares that the water supply had been poisoned.'[1]

Thomas and Godfrey volunteered first. This meant the immediate loss of both her baby and the son whose education she had committed to so wholeheartedly. George Frederick remained at home, a tailor, not called to duty yet. Ralph Denison kept the bicycle shop going in his younger brother's absence, confident that both boys would return.

Godfrey had enlisted a week after the appeal from Lord Kitchener, Secretary of State for War. He was one of the 750,000 men who flooded to recruitment offices in August 1914 for the new armies to expand on Britain's tiny standing professional army. He was placed in the 11th Field Company of the Royal Engineers and found himself shipped from the Isle of Wight to France. In the *Isle of Wight County Press* Roll of Honour, printed in October 1914, Godfrey's name appeared alongside that of Aubrey Tennyson, son of Hallam, with Tennyson's poem 'A Call to Arms', hitherto unpublished but

1. Panikos Panayi, *The Enemy in our Midst: Germans in Britain during the First World War* (New York/Oxford: Berg, 1991), p. 154.

submitted by Hallam in support of the men making their way to the Front. The seemingly unavoidable nature of the call of the conflict to the young men of the sleepy rural idyll of Freshwater seemed emphasised by an unpublished and undated fragment of Tennyson's work – set to music by Emily Tennyson and used to promote heroism twenty years after the Poet Laureate's death.

> Up stout limb'd yeoman, leave a while
> The fattening of your cattle –
> And, if indeed you wish for Peace,
> Be ready for the Battle!
> To fight the Battle of the World
> Of progress and humanity,
> In spite of his eight million lies
> And bastard Christianity!
> Are you ready, Britons all,
> To answer foes with thunder?
> Arm, arm, arm!

Godfrey was stationed in the Pas de Calais region of northern France where the company spent a wet season up until Christmas when the weather turned cold and bright. In a very short amount of time Sapper Gilbert had become Lance Corporal Gilbert, a promotion that must have made his family at home proud, if no less concerned. Away from direct conflict, the camp at Le Touret must have seemed relatively safe as the war crept into 1915. However, it was not the enemy that proved the threat.

The company diary for 11 January recorded the tragic event that shattered lives in the unit. That evening, Sergeant Jones of the company took a section of men to stack sandbags in a storage shed that held hand grenades, gun cotton and other stores. Godfrey worked alongside fellow sapper Charles John Collett to move the bags into the shed by the light of a candle hurricane lamp. Collett

had come from a similar background to Godfrey's; his father had been a labourer in Oxford where he had been born in 1882. The Collett family was large and Charles's father had found occupation as a gas stoker, taking him off the land into more urban employment. Determined for a better life, Charles had joined the marines and trained in Chatham. Transferring to the Royal Engineers, he found himself at Godfrey's side on that fateful night in January 1915, just as the hurricane lamp tipped over.

The diary records that at 6pm, as two further sections were preparing to venture out to work in the darkness of the crisp winter night, first one then another explosion rocked the camp. In a moment the shed was levelled and every member of No.1 platoon was either killed or injured. Sappers Brown, Bustable, Coppin and Edwards were killed immediately. Collett was missing, and Godfrey was gravely injured. The survivors were found and given first aid in a nearby billet but their injuries were beyond the capabilities of the staff on site. A motor ambulance rushed the men, including Godfrey, to Béthune five miles to the west. The company would have to wait until daylight to locate the lifeless body of Sapper Collett, who had been blown clear across the camp into a pond. By that time Lance Corporal Godfrey Searle Gilbert had died of his injuries, aged only twenty-four. The fact that his death had been caused by gun cotton, the same thing that when dissolved as collodion had enabled the immortalisation of his mother, was an unpleasant ironic coincidence. No details of the accident were repeated in the papers, the *Isle of Wight County Press* simply extending their sympathy to Mary and Tom Gilbert of Opawa Cottages, Freshwater, on the death of their son, remembered for the bright and interesting letters he had often written to the paper.[2]

Anti-German feeling grew swiftly, and the Government felt overwhelming pressure to detain foreign nationals who had made Britain their home in more peaceful times. Articles reflecting

2. *Isle of Wight County Press*, 6 February 1915.

this hatred ran in local newspapers, including a piece entitled 'German Military Rule' in the *Isle of Wight County Press* on 25 September 1914:

> Before the time of the present war, when few people had any idea of the ruthless methods and atrocities of German soldiers in a country they are invading, the opinion was sometimes expressed by some among the poorer classes in England that they would not be worse off if the Germans did conquer this country. One doesn't hear that now.

There followed an example of how German soldiers now occupying Belgium had been instructed to extract respect from the civilians 'by any method', and that resistance was met with force and atrocity.

LEFT: Thomas Harold Herbert Gilbert, *c.* 1910s
RIGHT: George Frederick Gilbert, *c.* 1910s

It is not surprising that by the time of his young brother-in-law's death, Charles Platte had been removed to an internment camp. While there, as a token of his concern for his two remaining brothers-in-law engaged in combat he fashioned wooden boxes that could contain candles, letters and tokens from home for them to take to the front. The initials of Thomas Harold Herbert and George Frederick were inlaid expertly on the fronts, and on the lids was a small inlaid picture of a house in an idyllic landscape – the homes he wished his brothers-in-law to return to safely.

Wooden boxes made by Charles Platte for his brothers-in-law George Frederick and Thomas Harold Herbert Gilbert

Charles returned to the small village after being released at the end of the war, but it would be many years before the villagers truly felt able to trust the German in their midst, despite the fact that he had lived and worked and shown his prize-winning chickens among them since the turn of the century.[3]

The urgency of war brought another of Mary's children to the altar in 1916, as Adeline married Lance Corporal Herbert

3. Charles Platte applied for naturalisation in 1923, but in a 1933 article in a local paper he was still referred to as 'the German'.

George Earl, who had already seen the world in his service with the Royal Engineers before the war. The rush to the altar might have been prompted by the dangers that Earl faced, which resulted in him not only being promoted to sergeant but also receiving the newly created Military Medal for bravery.

A brief lull in the horrors of the war came in the form of artist Ida Southwell Perrin and her sculptor daughter, Muriel. Mary did not break her vow never to sit for a photograph again, even a family photograph. Part of the reason was that as her eyesight failed she could no longer see how she looked, and she did not

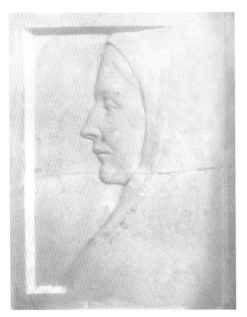

Blind Mary Gilbert (1917) Muriel Perrin

want a permanent record of herself that she could not see. Ida Perrin travelled to Freshwater to stay at the home of Benjamin Cotton, which faced Dimbola Lodge. An admirer of the photographs of Julia Margaret Cameron, Ida and Muriel sought out Mary on a visit in 1917. The result was a pencil sketch of 'Blind Mary Gilbert, aged 70' by Ida Perrin and a bas relief of Mary's unmistakable profile by Muriel, very much in the style of a Cameron photograph. Mary's grief after the death of her youngest child, Godfrey, is almost palpable in the images.

Thomas's wooden box returned with him to France with the Royal Garrison Artillery which he had joined in 1914. For him, quiet and studious, the 'Gambadiers' provided mental stimulation, despite the danger: it meant hours of plotting the trajectories of 6-inch shells, as part of a siege

Heavy howitzer being fired in France

battery. His unit was equipped with heavy howitzers that fired large calibre high explosive shells over long distances. Days, months and years were spent shelling the enemy in order to destroy strongpoints, artillery pieces, machineguns, shell dumps, stores, roads, railways and men, while the opposing artillery attempted to do just the same to you. The field diary of Thomas's unit for 1917 is filled with the plotting of which distant target to shell. When the shells flew, the sound was deafening and unrelenting: 'The shells sound like trains rushing overhead: for the infantry the sensation is like nothing so much as standing under a railway bridge on a busy line.'[4] Being shelled was physically and mentally gruelling: the din of the guns 'is terrific. Normal conversation would be impossible and the shock of each explosion, even at this distance, tugs at loose clothing and equipment.'[5]

4. Richard Holmes, *Tommy: The British Soldier on the Western Front 1914–1918* (London: Harper Perennial, 2005), p. 10.
5. ibid.

Soldiers firing the great guns learnt to keep their mouths open in order to equalise the pressure and protect their eardrums from bursting. In among this cacophony was Thomas Gilbert, an unlikely soldier, but not alone, in that: the Royal Artillery 'attracted a good proportion of steady, slightly introspective men who would never have joined the army in normal times, but took themselves and their new profession seriously'.[6]

The War Diary of the 282nd Siege Battery for 1917 paints a picture of life as a gunner. Swapping between entries about the amount of shells they have fired and their success, and the hours of shelling they endured, one is left feeling that the life of a gunner was not the archetypal experience of a First World War soldier. The death toll for the units seems remarkably low, losing individuals rather than swathes of young men, but the danger was there nevertheless. Fighting by Thomas's side was Samuel Rochelle, a farm labourer from Shropshire. Samuel had married his sweetheart Margaret in April 1914 and had not rushed to join up, unlike the Gilbert boys. His son William was born in 1915, and Samuel had finally been called up in the summer of 1916. A year later, in September 1917, he was killed when a shell exploded prematurely in the gun next to him. Ten days later, a fellow gunner, thirty-six-year-old William Hems died of his wounds after a barrage, leaving a widow and young son at the pub they managed together, the Honeysuckle Inn in Wigan.

Thomas withstood shelling, night gas attacks, and the guns, badly worn and past repair, becoming stuck in the mud of the French/Belgian border, and found himself pulled back from combat at the beginning of 1918 for training. The Germans had changed the format of their system of defence, and that required a new response and fresh thinking. Already embracing new technologies, Thomas's battery were taking radio observations from aeroplane spotters to direct their fire on the distant enemy. By March 1918 'came the

6. ibid., p. 417.

first reports of Gunners drawing up their own radios to be manned by Gunner operators'.[7]

By then the exhausted troops on both sides were looking for movement; for the first time the allies established a unified command under the direct command of the French General Ferdinand Foch. On 27 March the battles commenced in which the Royal Artillery were heavily involved in reacting to the German Spring Offensive, what would ultimately be the last of the war. General Sir Martin Farndale later wrote: 'records are scarce for the fighting of these two days, and this is not surprising. Men were weary, confusion reigned, the enemy was everywhere.'[8] On the same day, Thomas died at his gun on the Belgian border when a shell struck it. In a letter home from the major of the battery his parents were assured that his death would have been instantaneous. The brief mention of his death, among the many others listed on that day in the *Isle of Wight Country Press*, says that Thomas was held in high esteem by those who knew him, and special sympathy was sent to his widow Ethel.

After the death of Thomas and Godfrey, two Gilbert brothers still remained in service. Having left Freshwater for a career as a grocer's assistant in London, John joined the Royal Engineers, served his time in the Territorial Royal Field Artillery in India,[9] and returned to his life, to marry Dorothy in the following decade, only returning to the island on the eve of the next war.

George was thirty-five when the army finally called him up for service. Although he was a small, slight man with terrible eyesight, he was claimed by the Royal Engineers and taken for training to Liverpool in the winter of 1917. Sapper Gilbert was put through

7. Sir Martin Farndale, *History of the Royal Regiment of Artillery: Western Front 1914–18* (London: Royal Artillery Institution, 1986), p. 260.

8. ibid., p. 273.

9. No further information on John William's war can be established, and this fact, taken from a piece on Godfrey's death, should be queried, as it also listed Thomas's position as a corporal in the Royal Flying Corps.

his paces; his health was just passable, so he was placed on anti-aircraft duty with Tyne Electrical Engineers, then at Gosport, using the searchlight to secure the Solent like a trench. The night work began to take its toll, and George was transferred to hospital complaining of pains that travelled up his legs through his back into his head. His nerves were jagged and his confidence lost, and he was diagnosed with nervous debility, known as 'neurasthenia'. His subsequent medical records show that the army both tried to care for him and attempted to minimise his troubles, grading him at only 30 per cent disabled by his mental condition. He was treated and sent back to his work, then treated once more when it became too much for him. After the second treatment he was returned to the Royal Engineers and his searchlight.[10]

The loss of Thomas, the one to whom Mary had given so much of her love and time and of whom she had been so proud, marked a change in her attitude towards the war and her sons. The fragile George was retrieved from Gosport in the August of 1918 and married to his fiancée, Charlotte Elizabeth Smith. It was known in the family that George had not felt the impetus to marry Charlotte as strongly as his mother had wanted it, but he was fetched from the mainland and delivered to All Saints' Church, with the blessing of the Tyne Electrical Engineers. In the wedding photograph, taken in front of a sheet, George stands in full uniform beside Charlotte. On his other side are his father and his brother Ralph, together with Margery and Adeline, clutching her son Herbert, born two months after Thomas's death. Missing from the group is Mary, her place filled by her daughter. She had brought George back and he had married; still she would not appear in the photograph.

Ralph was given a reprieve from service at his tribunal in September 1918. Testimony was given by Mary that she was widowed, and that he was the last son left to support his blind

10. From George Frederick Gilbert's World War I Pension Records, on the Ancestry website.

mother. The army had two of her sons serving and had claimed the life of two, so she begged for Ralph to be left at home to run his motorcycle and bicycle business, a plea that was granted. George and John were serving at the time, but it is unclear whether Mary lied about being a widow or did not correct it when it had been assumed. Either way, one son remained at home.

George Frederick Gilbert and Charlotte Smith's wedding
From the left, Ethelburt and Charlotte Smith, the bride's parents, unknown friend of the bride, Charlotte and George, Ralph Gilbert and Margery Platte (standing), Thomas Gilbert and Adeline Earl, holding baby Herbert (sitting)

The Three Marys

Mary Ryan, or Lady Cotton as she had become, did not live to see old age. She returned from India with her four children in 1874 and did not go back to India and her husband until the end of the century. Henry Cotton was Assam's Chief Commissioner by then, and working hard to establish some sort of fair working conditions and pay for the indigenous tea plantation workforce. Although defeated by vested interests, he was knighted for his

Lady Cotton and her Children (1879)
Philip H. Calderon

work in 1902, and Mary, former Irish beggarmaid, rose to outperform even Julia's dreams for her by becoming Lady Cotton. Her charity work made her beloved by the people of Nottingham, but years of travelling and financial worries took their toll. After a year or so of ill health, she died in the autumn of 1914, just as the Gilbert boys were heading to France and war. Her passing was mourned in the local press of Nottingham, where her husband had been a Liberal MP on the family's return.

Mary Kellaway likewise did not remain in Freshwater, although her travels were less exotic than Lady Cotton's. Unlike Mary Ryan and Mary Hillier, Mary

Kellaway did not remain with Julia until marriage or the lady's departure: by 1871 she had crossed the Solent and was working in Portsmouth as a maid with Elizabeth Kellaway, another cousin, in the household of Mary Moresby, an elderly woman of independent means. She was married from the Moresby household to William Nightingale, a grocer and cheesemonger from Cambridgeshire, on 25 April 1871, in St Clement's Church, Kensington, London – a new church, built in 1867. The couple were married by the first incumbent.

Their daughter, given the name Florence, as was the fashion to pay tribute to the famous nurse, was born in 1876. The Nightingale family seem to have been comfortable and reasonably prosperous, but suddenly in 1886 at the age of forty-one William died, leaving Mary alone with their ten-year-old daughter to fend for themselves. In August 1890 Mary married again, to Charles Luff, a gardener, who was a widower. The union was witnessed by Florence. Florence herself married in 1898 – no longer Florence Nightingale but the slightly less impressive Florence Jones. Henry Walter Jones was a grocer like Florence's father, and they lived a long and happy life in St Mary's Croft in Wanstead (properties that are now valued at over £1m each). Florence gave birth to Trevor in 1905 and Gwyneth in 1909. The last we see of them is the 1911 census, where their seemingly affluent life is supported by three servants. Florence, the daughter of Mary Kellaway, moved from being the daughter of a servant from a long history of domestic servants and agricultural labourers to being lady of a house with staff of her own. Like Mary Hillier, Mary Kellaway's dreams for her own children were more expansive than a life of service in Freshwater. Like Mary Ryan, however, she did not live to spend a contented old age with her grandchildren.

In 1902 Mary Luff, listed as a former housekeeper, born in Freshwater, Isle of Wight, had mental health issues so severe that she was diagnosed as 'lunatic', aged fifty-one. There were other

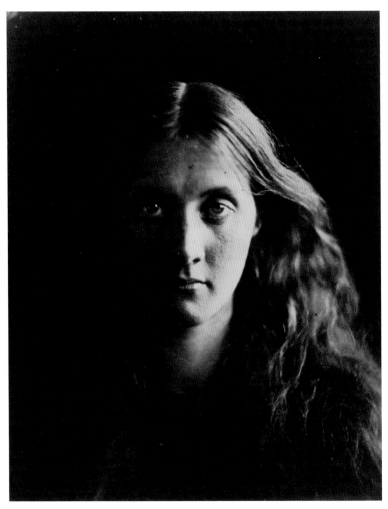

Julia Jackson (1867) Julia Margaret Cameron

instances in the Kellaway family of severe depressive and manic behaviour. In 1893 Mary's brother Oscar attempted to kill himself in a barber shop by walking in and picking up a razor which he held to his throat;[1] he then attempted to throw himself off Freshwater cliffs. Another brother, Eli Kellaway, was drunk and disorderly throughout his life, leading to the sad headline 'Eli's Weakness', in the *Hampshire Advertiser* in 1906, after what seems to have been yet another arrest.[2] In 1915, another brother, Arthur, employed as an assistant in the military canteen, slashed his throat with a razor in a sad echo of Oscar's attempt.[3] Mary was eventually released in 1913, possibly to the care of her wealthy daughter, and she died three years later.

Despite the passing of many of the figures from the golden years at Freshwater, a new generation was taking an interest in the myths and legends of the artistic and literary community there. On Sunday 7 January 1923 Virginia Woolf wrote to Vita Sackville-West: 'I hope you'll come and look at my great-aunt's photographs of Tennyson and other people some time.'[4] Virginia, daughter of Julia Jackson and granddaughter of Maria 'Mia' Pattle, had inherited a sizeable collection of portraits of her mother by Julia Margaret Cameron. Vita obviously showed interest, and they arranged to see them at a dinner party in the house of Virginia's sister, Vanessa Bell. This renewed interest led Virginia to the final draft of what would become the play *Freshwater: A Comedy*. She had been working on it from as early as 1919, researching the life of her great aunt as a distraction from grappling with *Mrs Dalloway*. The result was finally shared with her sister in the summer of 1923 and acted out with friends that Christmas. It was severely redrafted before being performed again as one of a cycle of plays

1. *Isle of Wight Observer*, 25 March 1893.
2. *Hampshire Advertiser*, 4 August 1906.
3. *Isle of Wight Observer*, 15 June 1915.
4. Virginia Woolf, *The Letters of Virginia Woolf*, ed. Nigel Nicholson and Joanna Trautmann, III, *1923–28* (New York/London: Harcourt Brace Jovanovich, 1975), p. 4.

performed at Vanessa Bell's studio in Fitzroy Street in London, during the 1930s. On the evening of 18 January 1935 there was a particularly packed studio eager to view *Freshwater: A Comedy*, beginning at 9.30pm. Based on Julia and Charles's ever more dramatic attempts to leave for Ceylon and the ill-fated marriage of Ellen Terry and G. F. Watts, the play featured a housemaid called Mary Magdalene, played by Virginia's niece, Ann Stephen.

The play is full of in-jokes about the three great figures of Victorian Freshwater – Tennyson, Watts and Cameron – and is a three-act joke at their expense, albeit one that could be seen as affectionate. However it could also be seen as Virginia Woolf reclaiming the endless stories of this golden age in the aftermath of the Great War. These figures of Victorian art and literature are reduced to caricatures, with Watts's disastrous first marriage to Ellen Terry stretched to 1875 and Julia's attempts to leave Freshwater complete with coffins. The figure of Mary, the maid, is a conflation of Mary Hillier and Mary Ryan, with a sly remark in the first act about the 'Earl of Dudley' who is waiting for Mary in the kitchen, obviously a nod towards Lady Cotton.

The involvement of their circle in what was at this point a private play exposed new people to the images of the old, familiar elite. Published in 1926, Virginia Woolf and Roger Fry's *Victorian Photographs of Famous Men and Fair Women* marked an interest from a new generation not only in the achievements of the nineteenth century but also in the follies. In Julia and her colourful life Virginia Woolf found much material. The plates, entitled 'Victorian Photographs', lead with images of Sir John Herschel and Henry Wadsworth Longfellow, not to mention Tennyson, Watts and ill-fated Frank Charteris, as all representative of 'Famous Men'. The fair women are predominantly members of the family and close friends, including a few images of May Prinsep, by this time Lady Tennyson, and 'Mrs Leslie Stephen', mother of Virginia Woolf. Mary Hillier appears more than the other 'fair women' in

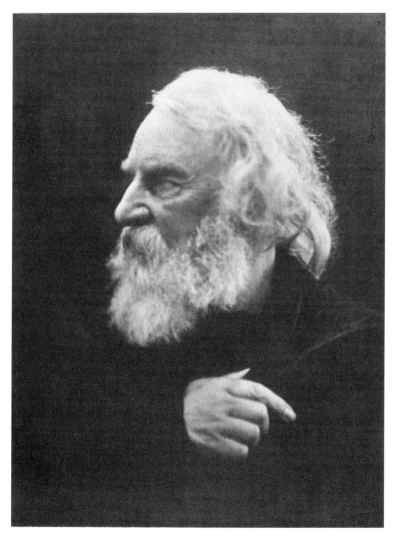

Henry Wadsworth Longfellow (1868)
Julia Margaret Cameron

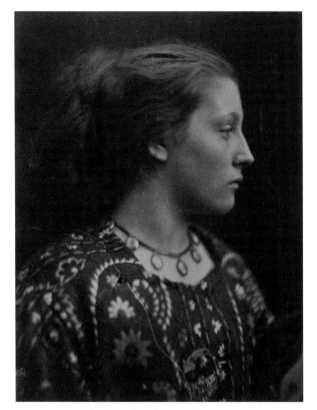

Sappho (1865) Julia Margaret Cameron

her guise of Madonna, together with *Sappho* and the sentimental *Pray God Bring Father Safely Home,* although she is not identified as the model in the last image. The commentary on this and the *Death of Elaine* has a negative edge, echoed in the reviews of the book. One was filled with nothing but praise for the portraits of the men, filled with 'strength and vigour', but felt the 'fancy subjects … illustrate the weakness of her technique. They are interesting but unattractive, whereas the portraits are of real permanent value.'[5]

5. *The Scotsman,* 13 November 1926.

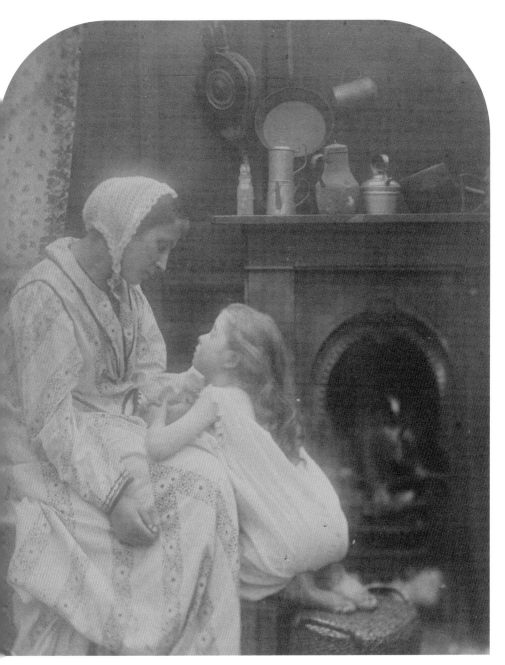

Pray God Bring Father Safely Home also known as *Three Fishers Went Sailing into the Deep* (1872) Julia Margaret Cameron

This interest in Julia's photographs at the publication of the book led to a local newspaper exclusive on the identity of the model in so many of Mrs Cameron's photographs. 'Vectis' writing in the *Isle of Wight County Press* reported that the wife of Mr Tom Gilbert was the woman in question. Now seventy-eight years old, blind and afflicted with rheumatism, but still possessing the charm and beauty which made her a favourite subject for her mistress's camera over half a century before. Mary admitted that 'she really detested the sittings, but was always a willing sufferer as she felt, to use her own words, that if it gave pleasure to others to photograph her, it was her duty to put up with the inconvenience.' Mary's memories of the great and good she mixed with as maid at Dimbola Lodge are given with names including Darwin, Longfellow and Tennyson. Her memories of Watts are unsurprisingly warm, remembering her husband's employer as 'a fine little man with a lovely face and wonderful eyes'.[6]

Julia Gilbert returned home to be her mother's companion in her old age. Tom continued to tend the garden, and Mary allowed local children to come in and gather apples for 'a 'apenny a 'atful'.[7] Mary's other children were married, some with children of their own, but Julia remained at her mother's side, as constant as Mary had been to Julia's namesake. When Julia died suddenly of peritonitis in May 1929, the shock was profound, compounded by the loss of Tom just a few months later. Despite these blows, Mary remained a central figure in village life, loved by her grandchildren, to whom she taught piano when they came to tea. Even in old age, when she was 'a martyr to rheumatism and had suffered blindness for some years, Mrs Gilbert still retained much of the beauty which made her the favourite subject of her mistress' photographic art'.[8] Her death in 1936 further severed the links with that long lost golden

6. *Isle of Wight County Press*, 3 April 1926.
7. Hinton, *Immortal Faces*, p. 60.
8. Obituary in *Isle of Wight County Press*, 18 April 1936.

age, and her obituary in the *Isle of Wight County Press* mourned the passing of one who could claim 'close associations' with Tennyson, Watts, and the 'famous intellectuals who favoured Freshwater with residence 60 years ago'.[9] George Gilbert's daughter Muriel, taught by her grandmother, played the organ for the service, accompanying the singing of 'Jesu, Lover of my Soul' and the voluntaries. The large congregation filling All Saints' in Freshwater then witnessed Mary's interment in the graveyard within sight of the graves of Lady Tennyson, the Prinseps and even little Adeline Grace Clogstoun. Not far from her grave is the war memorial that has Thomas and Godfrey's names carved upon it. Her stone still clearly reads: 'Her children rise up and call her blessed'.

LEFT: War memorial bearing the names of Thomas and Godfrey Gilbert
RIGHT: Gravestone of Thomas and Mary Gilbert, All Saints' Church, Freshwater

9. ibid.

E VEN IN DEATH MARY'S NAME was not forgotten easily, or separated from that of her mistress. Beyond the scope of the private theatrics in *Freshwater*, Virginia Woolf dwelt on the character of her great aunt in characters such as Queenie Colquhoun in *Night and Day*, written in 1919 around the time that *Freshwater* was formed as an idea in Woolf's mind. The Hilbery family, modelled to some extent on the Prinseps, exist in the ideal of Melbury House, modelled on Little Holland House. Photographs of the old days transfix the heroine, Katharine Hilbury:

> The faces of these men and women shone forth wonderfully after the hubbub of living faces, and seemed, as her mother had said, to wear a marvellous dignity and calm, as if they had ruled their kingdoms justly and deserved great love. Some were of almost incredible beauty, others were ugly enough in a forcible way, but none were dull or bored or insignificant.[1]

The photographs she describes are, on the face of it, ones of 'the great and the good', the Establishment, but within the societal levelling of Julia's images the beauties could equally have been the

1. Virginia Woolf, *Night and Day* (New York: Harcourt, Brace and Company, 1920), p. 116.

maids of Freshwater, especially when they were dressed identically to the ladies.[2]

Echoes of Virginia Woolf's portrayal of her great aunt as scatty and pushy, together with Mary's bovine docility, can be heard in Lynne Truss's *Tennyson's Gift* which expands upon the conceit. Taking place just a few months after Julia's 'first success' in 1864, the main thrust of the story is a stuttering Charles Dodgson's problematic visit to Freshwater in order to present the titular gift of his manuscript to the Poet Laureate, and the veritable Wonderland that he encounters there. At the centre of the maelstrom is the figure of Julia, forcing her servants to paint red roses white who joke that 'It will be off with our heads!' if they don't comply, echoing the fear of the Red Queen's servants in *Alice in Wonderland*.[3] Mrs Cameron herself is a bohemian – the very word drawing a shudder from Dodgson – who 'poses shop-boys and servants for her dreamy Pre-Raphaelite conceits'.[4] Such servants include the Tennyson maid Sophia, sister of 'Mary Ann' Hillier, causing tension in the Tennyson household as the maid is missing, posing as Titania in the glasshouse. Mary Ryan expresses resentment at Mary Ann's absences in the glasshouse 'pretending to be Mary Madonna or a Hangel [*sic*], or anybody else from the blessed Bible who never got their hands dirty doing her fair share of chores around the house'.[5]

The division is set between Julia's approach to photographic art and Dodgson's, and Dodgson does not hold Julia's approach in high regard: 'He had no idea why one maid should begrudge another

2. Mary Hillier in *Sappho* (May 1865) is wearing the same dress (or wrapped shawl) as Anne Thackeray, who became Lady Ritchie, in the group photograph of Anne with two children of 1868–72. Sophia Hillier in *Daughters of Jerusalem* (1865) is wearing the same shawl as Lady Elcho in *Lady Elcho as a Cumaean Sibyl* of the same year. There exist multiple examples of the maids wearing items of their mistress's jewellery, such as Mary Kellaway's brooch in *Yes or No* (1865) which is worn by Julia in a photograph entitled *Julia Margaret Cameron and her Watches* (1858) by an unknown photographer.

3. Lynne Truss, *Tennyson's Gift* (London: Profile Books, 2007), p. 3.

4. ibid., p. 7.

5. ibid., p. 14.

maid her chance to star in Mrs Cameron's photographs – especially when, in his own opinion, the photographs were dreadful, too big, and shockingly out of focus.'[6] Taking Woolf's hints that Mary was not intelligent, Truss's Mary Ann has a 'moony-long white face' and 'an unvaryingly stupid countenance'; Julia 'discovered great spiritual depth in Mary Ann's vacant open-mouthed expression'.[7] It is left to Mary Ryan, proving Henry Taylor's warnings correct by feeling uncertain of her position in the household and dissatisfaction with her place as a maid, to reveal the foolishness of Mary Ann. Mary Ann's romantic dreams of the young 'Herbert' come to nothing when he vanishes, leaving his hat in Ellen Terry Watts's room. Mary Ryan quickly realises that 'Herbert' is in fact Ellen: 'Poor fool, she thought, to be in love with Herbert, who beneath his jerkin clearly had big breasts and womanly hips. More foolish still to be jealous in this confusing, ludicrous way.'[8] By the end of the tale, the dim Mary Ann had not only had her heart broken but also slyly told Julia about some presumed ingratitude on Mary Ryan's part, without having the brains to see the implication.

Mary Ann of *Tennyson's Gift* is never present in the narrative without the disparaging description of her education, as 'Education had not been the main focus of Mary Ann Hillier's upbringing.'[9] In this way, Truss uses Mary Ann to represent all young women in service at this period, as G. F. Watts secretly ponders, 'Was there any profit in pointing out that half the maids in England were called Mary Ann?'[10] As in *Freshwater*, Mary Hillier is not important enough a subject to be the focus of ridicule: she is merely collateral damage in the mockery of her betters. The removal of Mary's agency in order to use her as a stick with which to beat the main focus of the mockery, Julia Margaret Cameron and her creation of an

6. ibid., p. 15.
7. ibid., pp. 15, 39.
8. ibid., p. 192.
9. ibid., p. 114.
10. ibid., p. 124.

alternative, independent art form and attendant scene, is a denial of Mary as an individual with her own story. This amalgamation of all maidservants being the same is directly contrasted to Mary Ryan, the girl never comfortable in service. Her 'real' story, speaking of her appropriate (in modern eyes) ambition beyond service, is included in the appendix in Truss's book. Mary Hillier's story is not.

By contrast, Helen Humphreys' *Afterimage* (2000) tells a far more sympathetic narrative of the relationship between maid and mistress. Irish-born maid Annie Phelan arrives to work in the house of photographer Isabel Dashell and her husband, Eldon. The house is unlike any other, with Annie called to model for the photographer, becoming her muse. The Dashells' marriage has become distant; Eldon sees this new maid as a way to find some comfort in his life as well as being the wellspring of inspiration for Isabel.

While it is easy to draw comparisons with Julia Margaret Cameron in Isabel Dashell, Annie is an amalgam of the two Marys who worked in her household. The images that Humphreys so beautifully describes and which form the structure of the book are taken from those posed by Mary Hillier, including the virtues Grace, Humility and Faith, and Sappho. Just as in *Annals of My Glass House* Julia described Mary as 'one of the most beautiful and constant of my models, and in every manner of form has her face been reproduced yet never has it been felt that the grace of the fashion of it has perished', Isabel Dashell presents Annie Phelan as a guest at her dinner party, allowing her maid to become a living exhibit: 'Every time she looks up, someone else is staring straight at her, unabashedly, as though she herself was a photograph, a portrait and not a living person at all.'[11]

Taken from the points of view of both mistress and maid, often switching between them within a scene, there is sympathy with both women who struggle to understand each other while feeling a deep connection. For Annie, she has the chance to be more than a

11. Helen Humphreys, *Afterimage* (London: Bloomsbury, 2000), p. 193.

maid, to be important to someone for the first time. For Isabel, she has a complicated mixture of a friend, a child, and an inspiration for her art.

Although the Dashells are obsessed with the past, Isabel with her scenes of Classical literature and Eldon with the records of past polar explorations, both are committed to the future, a future expressed through the personal growth of Annie from a maid to an educated, opinionated young woman. Isabel defends her art against her neighbour, Robert Hill, an establishment painter, who sees photography as a fad, a threat, the future he doesn't like: 'He is so afraid that she is at the beginning of what he is at the end of, that her success will ultimately mean his failure.'[12] In this way, Annie Phelan bears more resemblance to Mary Ryan and her class movement from beggar to lady. Annie Phelan's ambitions are less obvious, and the hidden stories of each character are both revealed and obscure. The photographs that provide the framework of the story, from Guinevere to Ophelia and the inevitable Madonna, are at odds with the lives of those involved in the images, reflecting the reality that the photographer takes pictures despite the realities of life, rather than in denial of them.

The staging of the dreamy ideals of fictional and biblical proportions while dealing with death, loss, longing, financial peril and criticism in a medium that is difficult, physically challenging and dangerous is nothing short of an act of rebellion for both mistress and maid. In this way, the enduring appeal and fascination of Julia Margaret Cameron and Mary Hillier, their relationship, and the performative expression of their mutual art are an acknowledgement of this feat. In modern reviews of exhibitions and books on the subject of her art Julia is given credit for 'breaking rules of focus and composition, and sending the (chiefly male) artistic establishment into a frenzy'.[13] Julia's gradual acceptance into

12. ibid., p. 198.
13. *Daily Telegraph*, 26 November 2015.

the sphere of what we understand to be 'Pre-Raphaelite' would no doubt have gratified her.

In 1975, the same year as the Herschel album was purchased for the nation, the BBC television drama *The Love School* featured an array of her work, albeit incorrectly placed in 1850. The same year, 1975, also saw the publication of Graham Ovenden's *A Victorian Album*, chiefly based upon another of the albums, this time one given to Maria Pattle.[14] In the introductory essay by Lord David Cecil a direct link is drawn between the Pre-Raphaelite artists' habit of using living models and the use of people like Mary Hillier and little Freddy Gould as Madonna and Cupid.[15] It is now recognised that the power of Julia's art lies in her relationship with her subject:

> If, however, a majority of her pictures transcend their era and remain so fresh, striking and meaningful today it is because they express the irresistible power of human presence; these are pictures that capture the intense moment of engagement between artist and sitter, the mutual engagement that is timeless and universal.[16]

The acknowledgement of the bond between Julia and Mary, the admiration of the photographer for her subject and the willingness of the subject to suffer to fulfil her vision, is at the heart of understanding this moment in art. For Julia, Mary was more than 'the most beautiful and constant'. She was recognised as deserving mention in conjunction with the photographs: 'The very unusual attributes of her character and complexion of her mind, if I may so call it, deserve mention in due time.'[17] The connection of Julia to Mary through inspiration and image runs deeply through their

14. Also known as the 'Mia album' of 1863.
15. Graham Ovenden (ed.), *A Victorian Album: Julia Margaret Cameron and Her Circle* (London: Secker and Warburg, 1975), p. 5.
16. *V&A Magazine*, Autumn/Winter 2015, p. 66.
17. Cameron, Woolf and Fry, *Julia Margaret Cameron*, p. 59.

lives, from Julia's path to her art to Mary's stoic love through loss and rediscovery. Even after the departure of her mistress for her colonial Avalon and eternal rest, Mary perpetuated her role of image creator from necessity, despite shunning cameras. She assumed the guise of a blind widow in order to save her son from the horrors of the trenches, remaining true to the role for which she was most famous, that of devoted mother.

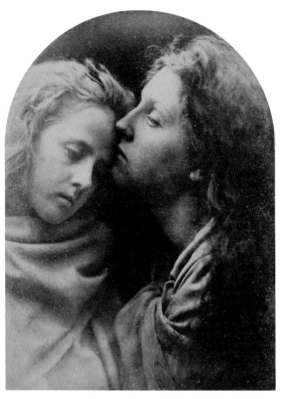

The Kiss of Peace (1869)
Julia Margaret Cameron

Further Reading

ON JULIA MARGARET CAMERON

Cameron, Julia Margaret, Woolf, Virginia and Fry, Roger, *Julia Margaret Cameron* (London: Pallas Athene, 2016)

Cox, Julian and Ford, Colin, *Julia Margaret Cameron: The Complete Photographs* (Los Angeles: Getty Publications, 2003)

Ford, Colin, *The Cameron Collection* (London: National Portrait Gallery, 1975)

Ford, Colin, *Julia Margaret Cameron: A Critical Biography* (Los Angeles: Getty Publications, 2003)

Gernsheim, Helmut, *Julia Margaret Cameron* (New York: Aperture Monograph, 1975)

Hill, Brian, *Julia Margaret Cameron: A Victorian Family Portrait* (London: Peter Owen Publishers, 1973)

Hinton, Brian, *Immortal Faces* (Newport: Isle of Wight County Press, 1992)

Lukitsh, Joanne, *Julia Margaret Cameron* (London: Phaidon, 2001)

Melville, Joy, *Julia Margaret Cameron: Pioneer Photographer* (Stroud: Sutton Publishing, 2003)

Mozley, Anita Ventura, *Mrs. Cameron's Photographs from the Life* (Stanford University, Museum of Art exhibition catalogue, 22 January–10 March 1974)

Olsen, Victoria, *From Life: Julia Margaret Cameron and Victorian Photography* (London: Palgrave Macmillan, 2003)

Rosen, Jeff, *Julia Margaret Cameron's 'fancy subjects': Photographic allegories of Victorian identity and empire* (Manchester: Manchester University Press, 2016)

Weaver, Mike, *Whisper of the Muse: The Overstone Album and other Photographs* (Los Angeles: Getty Publications 1986)

Wolf, Sylvia, *Julia Margaret Cameron's Women* (Newhaven/London: Yale University Press, 1998)

ON JULIA MARGARET CAMERON'S CONTEMPORARIES

Allingham, Helen and Radford, D. (eds.), *William Allingham: A Diary* (London: Macmillan & Co, 1907)

Liddell, Adolphus, *Notes from the Life of an Ordinary Mortal* (London: John Murray, 1911)

North, Marianne, *Recollections of a Happy Life: being the autobiography of Marianne North* (London: Macmillan & Co 1892)

Ritchie, Anne Thackeray, *From Friend to Friend* (London: J. Murray, 1920)

Seaton Watts, Mary, *George Frederic Watts: Annals of an Artist's Life* (London: Macmillan & Co., 1912)

Taylor, Henry, *Autobiography of Henry Taylor 1800–1875, vol. II, 1844–1875*, (London: Longmans, Green & Co., 1885)

Taylor, Una, *Guests and Memories* (London: Humphrey Milford, 1924)

Troubridge, Laura, *Memories and Reflections* (London: William Heinemann, 1925)

Troubridge, Laura, *The Story of Leonora* (London: W. Collins Sons & Co., 1930)

Weld, Agnes, *Glimpses of Tennyson and Some of his relations and friends* (London: Williams & Norgate, 1903)

Picture Credits

Index

Note: page numbers in *italics* refer to photographs and illustrations. Relationships in brackets are those of Julia Margaret Cameron, except for the Hillier and Gilbert families which refer to Mary Hillier.

A

Aberdare, Henry Bruce, 1st Baron 52
Adams, Jesse 136
Álámáyou of Abyssinia, Prince Dejátch 131, *132*
Allingham, William 55, 131
Archer, Frederick Scott 90
Ashburton Cottage, Putney Heath 65
astronomy 30, 36

B

Bayley, Henry 36
Bayley, Louisa Colebrook née Pattle (sister) 23, 36
Beadle, Samuel 22
Beadle, Virginie née l'Étang (aunt) 22, 29
Beeton, Mrs 82
Bell, Vanessa 199, 200
Bengal Obituary, The 22
Bentinck, Lord William 21
Besbold, Theda 82
Blunt, Wilfrid 47
Bourne, Herbert 34
Boyce, George Price 122
Bradley, Margaret Louisa 'Daisy' 91, *91*
Briary, The, Freshwater 147, 169, 174, 176, 178
Broadfoot, Major George 41
Bürger, Gottfried August 27, 36
Burne-Jones, Edward 52, 83
Byron, Lord 33

C

Cameron, Annie née Chinery (daughter-in-law) 150–51, *151*, *152*, 153–4, *155*
Cameron, Archibald (grandson) 142, 153
Cameron, Beatrice (granddaughter) 139, 140, 153
Cameron, Caroline (daughter-in-law) 153
Cameron, Charles Hay (husband)
 character 38, 47, 124, 161–2
 health and death 81, 170
 marriage 30–33, 36, 40–42
 in photographs *31*, *78*, 99–101, *101*, *102*, *171*
 residences
 Ceylon 65–7, 144, 161, 164, 165
 Freshwater 75, 76–7
 see also Dimbola Lodge, Freshwater
 in Calcutta 33, 36, 38, 41–2
Cameron, Charles (son) 65, 125, 165
Cameron, Donald (father-in-law) 33
Cameron, Eugene Hay (son) 40, 41, 42, 65, 67, 153, *153*, 164
Cameron, Ewen Wrottesley Hay (son) 40, 42, 65, *66*, 67, 150, 154, 165
Cameron, Hardinge Hay (son) *64*, 65, *163*, 164, 165–6, 169
Cameron, Henry Herschel Hay (son) 57, *57*, 65, 87, 149, *149*, 165, 169
 Julia Margaret Cameron (1870) *51*
Cameron, Julia Hay
 see Norman, Julia Hay
Cameron, Julia Margaret née Pattle *51*, *59*, *141*
 birth and early years 23, 24, 26, 27
 character and appearance 49–50, 55–6, 94, 133